Cat Life

Celebrating the History, Culture & Love of the Cat

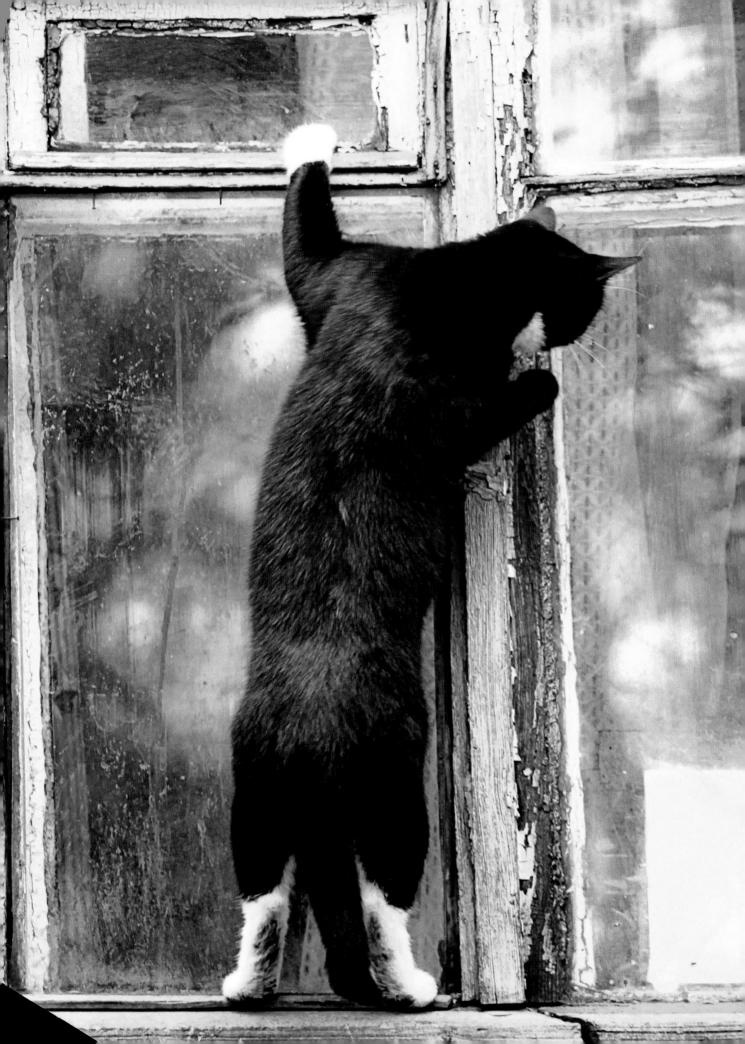

Cat Life

Celebrating the History, Culture & Love of the Cat

AMY SHOJAI
FURRY MUSE PUBLICATIONS

Copyright © 2019 Amy Shojai ISBN 978-1-948366-14-4

Sherman, TX 75091

All rights reserved under International and Pan-American Copyright Conventions. Published in the United States by Furry Muse Publications, an imprint of Amy Shojai, Sherman, Texas.

Illustrations and Photos on designated pages credited below are Licensed via DepositPhotos.com unless otherwise noted: Front and Back Cover Maine Coon cats © DenisNata

- 2: ©xload, cat at window
- 3: (PD-art) Peterborough Cat, via
- https://commons.wikimedia.org
- 4: @BartKowski, British Shorthair
- 6: Ophilfreez@gmail.com, 2 cats in round window
- 8: ©osalenko, blue eyed cat
- 10 ©tankist276, kitten on hind legs
- 13: ©YuliaAvgust, Lion; ©CoreyFord, Smilodon; ©PhotosVac, Pseudaelurus; ©ruskpp, Miacid
- 14: @GeoRge_Fotos, Sekhmet
- 15: ©olgasweet, tiger; ©Dink101, green-eyed cat
- 17: ©lifeonwhite, lion
- 18: ©lifeonwhite, lion and lioness roaring
- 19: ©GUDKOVANDREY, Siberian tiger with bird
- 20: ©davemhuntphoto, tiger; ©lifeonwhite, leopard
- 21: ©GUDKOVANDREY, cheetah; ©anankkml, jaguar;
- Oscheriton, clouded leopard
- 22: ©Coffee999, leopard; ©MattiaATH, lioness
- 23: ©VolodymyrBur, leopard
- 24: ©wrangel, rusty-spotted cat; ©wrangel, fishing cat
- 25: ©wrangel,Pallas's cat; ©Veneratio, Scottish wildcat
- 26: ©kyslynskyy, lynx(top), ©mikelane45, Canadian lynx (bottom)
- 27: ©OndrejProsicky, margay; ©fouroaks, Caracal; ©ammmit, ocelot
- 29: ©rysp, Egyptian cat statue
- 30: ©izanbar, cat mummy
- 31: ©zatletic. Hercules with lion
- 32: ©gianliguori, Chinese lion; the Palace Museum, Forbidden City, China
- 33: ©bloodua, Spinx and the great pyramid
- 34: (PD-art) Illuminated manuscript, via
- commons.wikimedia.org
- 35: Obelchonock, black cat
- 36: ©Georgios, Queen Victoria
- 37: ©tankist276. Scottish fold mom with 3 kittens
- 38: ©Farinosa, tabby Maine Coon with books
- 40: ©Iridi. Puss in Boots
- 41: ©chrisdorney, culpture of Dick Whittington and his cat; ©
- Georgios, Chaucer

- 42: ©RobSnowStock, The Owl And The Pussycat
- 42: ©Ancello, illustration of Cheshire Cat
- 45: ©steffen.fluechter.ewetel.net, Sculpture of The Bremen Town Musicians
- 46: ©Georgios, Napoleon
- 47: (PD-art)Durer, and study for da Vinci, via
- commons.wikimedia.org
- 48: (PD-art)Madonna with cat by Romano: (PD-art-life-
- 70)Steinlen poster, via commons.wikimedia.org
- 49: ©zatletic, detail from The Last Supper; ©Morphart, The
- Cobbler of Portsmouth engraving
- 50: ©Isantilli, San Marcos Basilica in Venice
- 53: (PD)Chessie the Chesapeake Cat. Bon Ami advertisement.
- via commons.wikimedia.org
- 54: ©mathes, Cat House in Riga, Latvia
- 55: ©vizland, Buddhist statue of lion
- 56: ©davidgn, Chinese Temple tiger with cub 57: ©Kruchenkova, black cat with pumpkin
- 58: ©pavelrock95.mail.ru, odd eyed white cat
- 59: ©Elizabetalexa, black and white cat
- 62: ©natulrich, kitten hanging from rope
- 64: ©Elizabetalexa, cat in grass; ©okiepony, cat running
- 66: ©iagodina, kitten in Sakura tree, pink flowers
- 67: ©krappweis, Bengal cat in leaves
- 68: ©ammmit, Pumas mutual grooming
- 69: ©OndreiProsicky, Snow Leopard
- 70: ©lko-images, cat on fence
- 71: ©vi0222, cat nose
- 72: ©asimojet, catnip
- 73: ©nataba16, cat drinking water; ©mdorottya, Himalayan
- cat in container
- 74: ©simurg, Maine Coon and Persian sniffing
- 75: ©darzyhanna, cat on cat tree
- 76: ©lifeonwhite, two cats with goldfish
- 78: ©virgonira, cat nursing kittens
- 79: ©bezkofeina, kittens with books
- 80: ©zennaster8, kitten with pumpkin
- 82: ©c-foto, fighting kittens
- 83: ©dnsphotography, playing kitten on back
- 84: ©Natalyka, Toyger kitten with broken plant

- 86: ©VladAli, talking cat
- 87: ©sorokopud, cat eating chicken bone
- 88: ©Lightspruch, cat in litter box
- 90: ©edu1971, veterinarian with cat
- 93: ©noonie, cat grooming
- 94: ©Yulu, cat peeing in sink
- 96: ©karvch, old cat
- 98: ©lanRedding, pet cemetery
- 99: ©izmargad, Sphynx
- 100: ©krappweis, Bengal playing with water
- 102-103: ©lifeonwhite. 3 Persian cats
- 104-105: ©FotoJagodka, 5 Burmese kittens
- 106: ©topten22photo, Diana Rothermel & Persian
- 107: ©iagodina, Abyssinian; ©lifeonwhite, American Curl
- 108: ©ylad star, American Shorthair
- 109: ©lifeonwhite, Balinese; ©cynoclub, Bengal
- 110: ©VadimBorki, Birman ©dionoanomalia, Bombay
- 111: ©tanitue, British Shorthair: ©mdmmikle123, Burmese
- 112: ©veloliza, Burmilla; ©lifeonwhite, Chartreux
- 113: ©FotoJagodka, Cornish Rex
- 114-115: ©lifeonwhite, 4 Devon Rex kittens
- 116: ©Cat'chy Images, Egyptian Mau: ©vanazi, Exotic
- 117: ©lifeonwhite, Havana Brown kittens; ©imzoodesign,
- 118: ©dionoanomalia, Japanese Bobtail
- 119: ©FotoJagodka, Maine Coon @LifeOnWhite, Lykoi 120: ©lifeonwhite, Norwegian Forest Cat
- 121: ©adogslifephoto, ebony silver Ocicat;
- 122: ©emprise, Ragdoll: ©cynoclub, Oriental Shorthair
- 123: ©kipuxa, Russian Blue; ©lifeonwhite, Scottish Fold 124: ©lifeonwhite, Selkirk Rex, Siamese
- 125: ©liveonwhite, Siberian cat; ©Seregraf, Singapura
- 126: ©evasilieva, Snowshoe: ©dionoanomalia, Somali
- 127-128: ©cynoclub, 5 Sphynx cats
- 129: ©averyanova, Tonkinese; ©Natalyka, Toyger
- 130: ©vi-mart, Turkish Angora
- 131: ©Amy Shojai, Karma-Kat, silver shaded tabby
- 133: ©2002Lubava1981, Siberian cat with kitten

PUBLISHER'S NOTE: Every effort has been made to ensure that the information contained in this book is complete and accurate. However, neither the publisher nor the author is engaged in rendering professional advice or services to the individual reader. The ideas, procedures, and suggestions contained in this book are not intended as a substitute for consulting with your pet's physician.

DEDICATION

This book is dedicated to the kitties that never find a home; in loving memory.

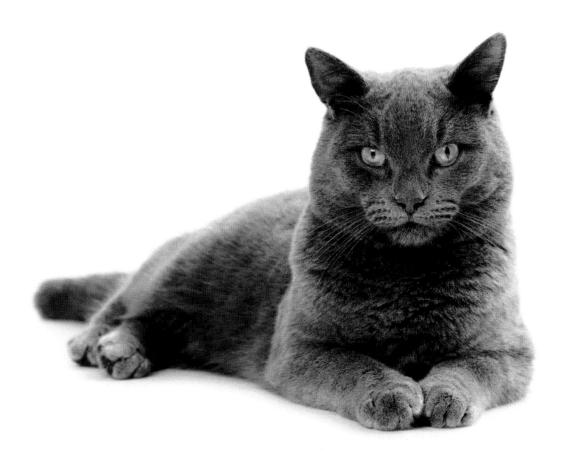

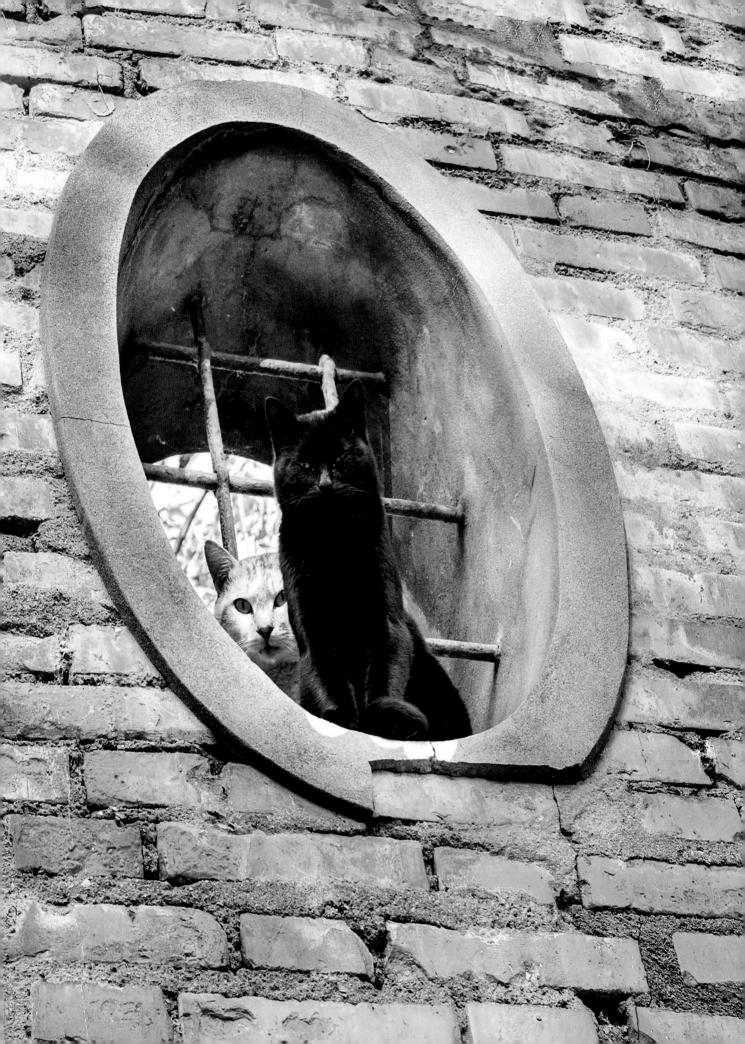

TABLE OF CONTENTS

	INTRODUCTION	9
ONE:	EVOLUTIONARY CAT	11
TWO:	CULTURED CAT	39
THREE:	PHYSICAL CAT	63
FOUR:	GALLERY OF BREEDS	101
	FURTHER READING	131
	INDEX	133
	ABOUT THE AUTHOR	136

Introduction

he cat is a being like no other. From the cave drawings of prehistoric felines to today's fancy show kitties, cats continue to fascinate people. Though a cat may choose to share her affection with a human or two, she will always remain that quixotic mix of unpredictability and individuality that challenges the understanding of the most patient among us. It is as if they know that when they first stepped into the human ring of firelight, they forever altered our history, influencing our religions, our literature, our art—our very lives.

Whether exalted, as in ancient Egypt, or reviled and persecuted, as during the Middle Ages, the cat has struck an emotional chord deep in the human imagination. He is the envied Wild Brother that cannot be tamed; the Gentle Companion that purrs a mantra to ease aching human souls; the Eternal Kitten that coaxes a smile from the stingiest of human hearts. We delight in our cats—and, we hope, they in us.

Steadfast ailurophiles rejoice that the cat has finally been returned to the pedestal from which she was once so cruelly thrown. Those only recently bitten by the "cat bug" may wonder why she was ever dethroned at all.

Perhaps in today's world, where blind loyalty to one's leaders is no longer expected, where questions are encouraged and individuality is applauded, the cat has finally come into her own. The cat is no longer a god, but neither is she a demon.

This book is for cat lovers everywhere. It is intended as both a basic guide for the neophyte cat addict and a supplement for veteran feline fans. It is my hope that these pages will delight and amuse, surprise and educate, and, most of all, celebrate the mysteries and marvels of all the wonderful cats that share our lives.

Try as we might, it is impossible for us to be indifferent to the cat. But whether we are cat champions or feline foes makes no difference to kitty. Cats are quite satisfied to share their lives with humans by simply being themselves—inimitable cats.

And that, dear readers, is more than enough.

One:

Evolutionary Cat

henever a cat takes possession of house and heart, it seems as though he has always been there. In fact, the cat has been around (in one form or another) even longer than people. Ancestors of the modern-day kitty have been found in fossils dating back fifty million years. These archaic predecessors, however, didn't look much like the purring mound of fur that dozes on your lap today.

Taxonomists love to categorize, and the abundant variations of cats found across much of the world give them ample opportunity to do just that. These scientists try to scientifically define the links between different kinds of animals. The first division within the order Carnivora is the family; cats are the family Felidae. Next, groups of animals within the family are divided according to structural similarities; each of these groups is a genus. Finally, animals within a genus are categorized by species, and some even further into subspecies. Because of the many subtle differences among members of the cat family, taxonomists do not always agree on exactly where a specific cat is positioned in the family tree; new genera, subgenera,

and subspecies are designated as newer variations are identified.

Cats are classified in the order Carnivora (meat-eaters), which had its origins near the dawn of the Cenozoic Era. About sixty-five million years ago, mammals called creodonts evolved with canine teeth for stabbing and sharp-pointed cheek teeth for chewing and shearing meat. The ancestors of creodonts appeared when dinosaurs roamed the earth. When the dinosaurs became extinct, creodonts developed into a variety of predators; some were large, wolf-like creatures, with long bodies, short legs, and clawed feet. Although they were slow-moving relative to cats, creodonts were efficient hunters. In fact, they were able to spread across much of the earth, flourishing for about nine million years. When slow prey was gone, creodonts had to switch to faster newcomer prey for food, the ancestors of the horse and deer. Fossil remains indicate that the creodont brain was quite small. They were so slow both physically and mentally that they couldn't adjust to the faster, much smarter prey, and eventually became extinct.

Dogs and cats had the ancestor? same imagine that's a fact that Kitty will try to deny. Just for fun. remind her the next time she swats Fido.

The earliest probable forebears of today's kitties evolved during the middle Paleocene, sixtv-one about million years ago. These forebears were insectivorous small. animals of the family Miacidae, which formed the two

branches that gave rise to all the families within the order Carnivora. Miacids were forest-dwelling creatures that were smaller than their creodont predecessors. However, miacids did improve on brain size and, subsequently, intelligence. Miacids were enormously successful carnivores; what they lacked in size they made up for in ferocity. The first miacids probably

looked like modern-day shrews, with short legs and long bodies. They probably had retractable claws and were at home climbing trees—just like today's house kitties. At the beginning of the Oligocene Epoch, about forty million years ago, a burst of evolution and diversification of the miacids produced all the modern families of the order Carnivora. These include members of the raccoon family the bear family (Procyonidae), (Ursidae), the dog, fox, jackal, and wolf family (Canidae), the weasel and badger (Mustelidae), the civet, genet, and mongoose family (Viverridae), the hyaena family (Hyaenidae), and of course the entire cat family (Felidae). All of these can be traced back to the pint-sized miacids.

Cat-like carnivores comprise two groups: the paleo felids (family Nimravidae) and the neofelids (family Felinae). Although cat-like in many anatomical features, paleo felids are not direct ancestors to modern cats. (For example, Dinictis was a paleo felid that was nearly the size of the modern-day lynx, with a brain smaller than that of modern-day cats. Its teeth were like present-day cats' teeth, too, but with larger canines.) Scientists split the Felidae into two subfamilies: Machairodontinae and Felidae. Both subfamilies had a common ancestor similar to Pseudaelurus, which lived in the early Miocene to early Pliocene Epochs about four to twenty-four million years ago.

Machairodonts had enlarged saber-like upper canines and began to appear in the early Oligocene Epoch thirty-four million years ago. These cats couldn't use their huge canine teeth unless the mouth was wide open. With the longest upper canines, Smilodon was the latest and most advanced saber tooth cat. Smilodon's large canines, in conjunction with massive neck and upper body muscles, were used to deliver lethal bites to soft-tissue areas of the neck or belly of large prey. Their prey were most probably juvenile

mammoths, mastodons, and thick-skinned mammals. Evidence suggests that Smilodon lived in social groups and could both roar and purr.

The Felinae evolved into cats

that were smarter, more adaptable, and swifter hunters saber-toothed than their brethren. One of the earliest Pseudaelurus, which didn't have huge saber-like teeth, and killed prey by a bite to the neck—like modern cats. Central Europe became home to a variety of lynxes and giant cheetahs; huge

tigers evolved in China; North America's forests echoed with the growls of giant jaguars; and an assortment of smaller cats developed and flourished over much of the earth. The fossil bones of Pseudaelurus look very similar to the bones of our smaller modern cats. All existing felines evolved from

animals like these.

kangaroo

Dinictis came into existence too

late to reach Australia. A nearly

parallel, yet separate evolution

among marsupials took place,

however, giving rise to prehistoric

"cat" versions of animals with

pouches. Fossils have been found

in Australia of the marsupial lion

Thylacoleo, a leopard-size animal

with stabbing incisor teeth.

and

teeth

saber

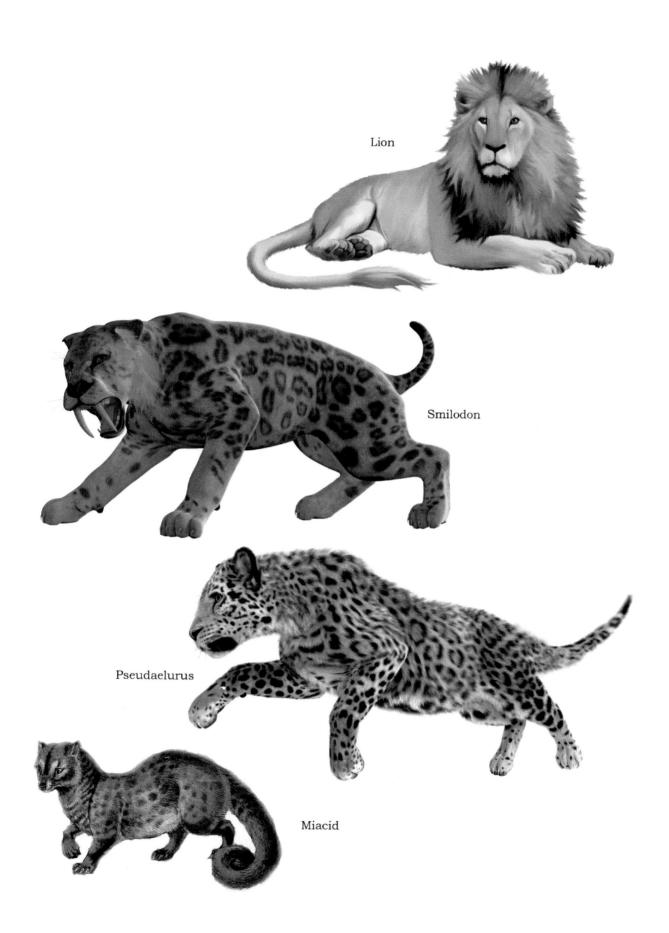

EVOLUTIONARY CAT - 13

Male cats are called "Toms," female cats are called "Queens." A cat has a "litter" of kittens, but a group of kittens is known as a "kindle" of kittens. Several cats together can be called a "clowder," "cluster," or "clutter" of cats.

About three million years ago, Felinae developed into the two distinct genera we recognize today, and they are grouped by size. Panthera includes lions, tigers, panthers, and jaguars. In addition, there are two big cats with such unusual differences that scientists have designated specific genera for each; Acinoynx for the cheetah, and Neofelis for the clouded leopard. Felis is the genus smaller cats, the including the domestic varieties. This means that the kitty sharing your sofa belongs to the family Felidae, genus Felis, species silvestris, subspecies catus. With a title like Felis silvestris catus, is it any wonder kitty carries such an air of importance?

Experts and scientists have argued for years over the direct ancestry of the domestic house cat. The Martelli's wildcat is a probable close relative but not the missing link we seek. Martelli's wildcat inhabited Europe and the Middle East and became extinct relatively recently (about a million years ago). Some scientists consider this animal a probable direct ancestor of our modern small wildcats, Felis silvestris. It is these modern wild cousins that are suspect, because they

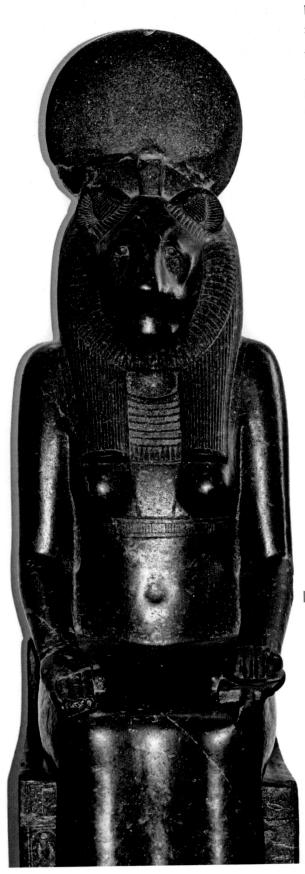

bear such a distinct resemblance to domestic cats.

Wildcats are found in Europe, Asia, Africa, and America, and are the same genus as domestic cats. For many years it was held that domestic varieties were direct descendants of the European wildcat or forest cat, Felis silvestris silvestris. However, although the European wildcat is superficially like domestic cats, the two species are very European different. The wildcat's body is more heavily built, its limbs longer, its skull broader, and its tail shorter and blunt, rather than tapered and pointed on the end like tails of domestic cats. The European wildcat is also nearly impossible to tame. Experts have since concluded that these factors eliminate the probability of its ancestry with close domestic cat.

Another contender is the Asiatic steppe wildcat, or desert cat, Felis silvestris ornata. This cat is smaller than the other wildcats and is found from the

Early Egyptians celebrated the lion, and later the cat, as symbols of power. This lion-headed goddess is Sekhmet, which means "the powerful." The lion often represented the sun god, Ra. Sekhmet, Tefnet, and Bast were Ra's daughters, and Bast became identified with the domestic cat.

Soviet Union south to central India. It is thought by some to figure in the genetic picture, perhaps in conjunction with the African wildcat.

The most likely origin for domestic cats, most experts agree, is the African wildcat, Felis silvestris lybica. Its tail is long and tapering like domestic varieties, and although it is slightly larger than house cats, it looks much more like them than does the European wildcat. Most of the mummified remains of Egyptian domesticated cats were of this African variety, which domesticates easily and will readily interbreed with domestic cats.

The cat species vary in weight from four pounds (1.8 kg) to more than six hundred pounds (272.2 kg). Big cats like this white tiger (above) rest with their forelegs straight out in front of them, leave droppings uncovered, and completely pluck bird prey before eating it. Most small cats (including domestic cats) curl their paws under their chest when at rest, bury their feces, and eat fur, feathers, and flesh, spitting out only the longest feathers of birds they catch.

Cats were most certainly domesticated 3,500-4,500 years ago; we have only to look to ancient Egypt to be convinced of this. However, experts speculate that cats came into homes as partners and pets long before ancient Egyptians began singing their praises, and scientists continue to search for proof.

Speculation is based on kitty remains found in human

settlements that predate the Egyptian era. Evidence indicates cats may have been domesticated as early as eight thousand years ago. A cat's jawbone discovered in 1983 at an excavation site in southern Cyprus dated at 6000 B.C. Because Cyprus has no native wildcats, experts theorize that the presence of the jaw must mean the cat was brought by human settlers. This could mean that cats have been enriching human lives nearly twice as long as previously believed.

In any event, cats have been around a long, long time. Their knowing attitude and aura of eternal agelessness are constant reminders that cats spring from the mystic beginnings of time itself. It's a fact kitty will never let us forget.

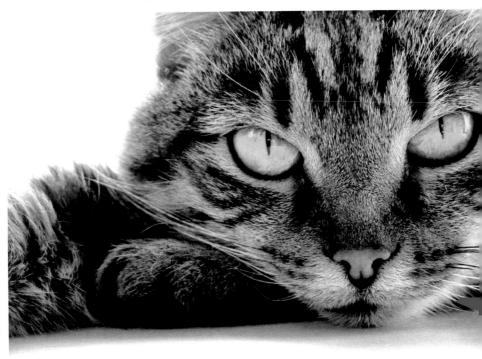

LIONS & TIGERS AND... CATS, OH MY!

The land bridge to Australia

evolving. Although Australia

several

have been given the name

"cat." However, the Tiger

Cat, (Dasyurus maculatus).

and the Western and Eastern

Native Cats, (D.geoffroii and

D. viverrinus) of Australia are

cats

indigenous

time

were

animals

was gone by the

prehistoric

species,

marsupials.

no

s your kitty calmly washes his whiskers, take a moment to consider: What exactly does that spritely, purring kitten have in common with other cats around the world? How are they alike—and what are their differences?

As mammals, all cats share certain similarities. Cats are warm-blooded, and they give birth and suckle their young. With subtle differences, most cats of the world are very much alike in behavior. The tabby that stalks and pounces on your ankle mirrors the stealthily stalking leopard that hunts to capture its dinner. The physical family likeness includes feline eyes set well forward in a basically short face; a lithe, muscular, fur-covered body; along with certain physiological specializations as well as behavioral similarities that distinguish cats the world over.

Members of the cat family are so closely related, in fact, that crossbreeding between species is quite possible. Wildcats often mate with domestic cats

and crossbreeding between wildcat species is likely to occur. The "leopon," a cross between a leopard and a lion, and the "tigon," a cross between tiger and lion, are frequently produced in zoos. However, crossbreeding between big-cat species in the wild rarely occurs, and new "breeds" are unlikely, since the hybrid cubs are often sterile. But the fact that such breedings take place is testament to the adaptability and similarity of cats around the world.

The skeletal structure of all cats are very similar, with only minor variations detectable by specialists. The most obvious distinction between wild and domestic cats is their disparity in size. This difference evolved in

part because large animals were the most available prey to wild cats. Zebra and antelope become kitty vittles only when cats are big enough to catch them. Size differences also make it possible for a variety of cat species to live near each other without stepping on each other's furry toes by competing for the same food.

Environment also dictates the distinctive fur coat each cat wears. Domestic cats display a tremendous variety of stripes, dots, spots, and swirls. Although evolution initially played a big role in decking them out, more recent colors are due to human taste and selective breeding, rather than any environmental adaptation.

environmental adaptation.

The house cat's wild brothers, however, depend on coloration for more than compliments. The dusty-colored sand cat blends into the dunes and scrub that make up its home; long fur that grows on the soles of its feet protect the pads and helps it navigate loose sand. If the sand cat had the bright stripes of the tiger or the characteristic coloring of the black leopard, it would not be able to sneak up on its prey. Each cat is marked in a

specific way to aid in its unique fight for survival.

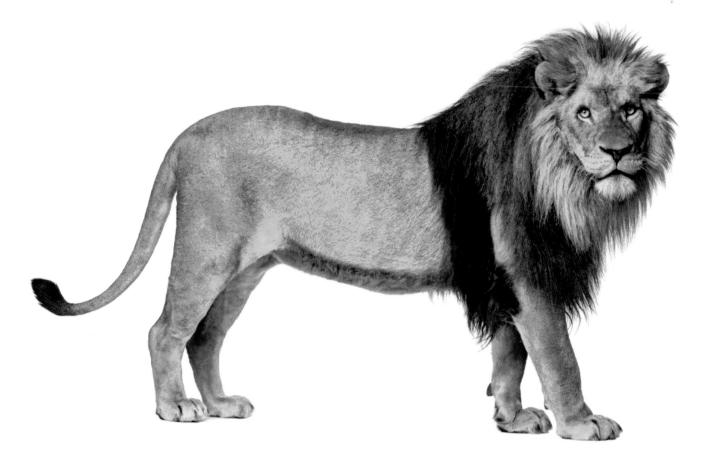

LION

No one would mistake the lion for anything else. Yet even though the lion may be ten times larger than your kitty couch potato, their behaviors are strikingly alike. The lion's tawny coat and imposing mane give a unique, regal appearance, but the intrinsic kitten quality lingers just below the surface. Royalty evaporates and is replaced by shades of purring kitten when King Leo washes behind his ears with a huge forepaw or dozes sleepily in the sun.

Lions grow up to ten feet (3 m) long, with their tail adding an extra forty-plus inches (one meter plus). Leo's short fur ranges from light buff to intense orangebrown (and sometimes white), and the back of his ears are marked with "false eyes" of black fur. Only the male has a mane, which can be shaded from yellow to black. The lion's mane is the only physical distinction of sex in the cat family, other than reproductive organs; in all other cat species, males and females look alike.

Lions are the only wild member of the cat family to live in social groups, called prides. The pride hunts as a team by chase and ambush. The female is the breadwinner, often chasing prey into another lion's killing embrace. Lions hunt by either night or day, but they are usually active only about four hours at a stretch and spend most of their time sleeping. (Sound familiar?)

Lions, like all cats, are extremely territorial. Vocalizations including coughs and growls, and impressive roars help establish territory. When a new male lion becomes dominant, he often kills the offspring of the previous male to set up his own hierarchy and to induce the females to go back into estrus, or breeding cycle.

The lion is the only wild cat that has a prolonged breeding cycle. Resulting overpopulation is controlled in a barbaric but effective fashion; the strongest eat first and remain strong; the weakest eat the leavings, consequently suffering low fertility and a high abortion rate, and many die of starvation.

When your kitty tires of playing on the drapes, she will search out a comfortable place to curl up and sleep the day away—just like a lion. Domestic cats also form communal societies, just like the lion. These kitty "prides" have been studied in large populations of unaltered domestic cats in farm settings. They are marked by dominance and hierarchy, territorial

disputes, and peaceful co-existence—just like lion prides. Domestic felines are a bit more liberated than lionesses, however, and may not deign to mate with the "king." Macho male cats, called toms, fight over territory in kitty prides, but even when they win, they don't always get the girl.

Female cats nurse each other's kittens as a matter of course, as do lions. Invading toms often kill undefended kittens as do their lion counterparts. This behavior is nothing new; it was recorded centuries ago in descriptions of the domesticated cats of ancient Egypt.

ROAR VS. MEOW

group of two chains of bones that link the larynx to the skull is quite different between the big cats (Panthera) and the small cats (Felis). In larger cats such as the lion, one section of these bones is made of elastic cartilage. A pad of tissue at the vocal cords allows the lion to vocalize a roar, which can carry over a five-mile (8-km) distance. In smaller cats, all the sections are inflexible bone, which can at most produce a scream. But smaller cats can purr vocalizing both on continuously, incoming and outgoing breaths. Exactly how cats produce the purr has fascinated humans for eons. Some experts theorize structures in the cat's throat, called vestibular folds or false vocal cords, make the sound by rubbing together when air passes through as the cat inhales and exhales. Another theory suggests purring is caused by a rapid contraction and relaxation of the muscles surrounding the voice box and diaphragm to produce turbulent air flow through the trachea. Others blame turbulent flow of blood through a large vein in the cat's chest, again caused by diaphragmatic muscle contractions; vibrations transmit via the windpipe to the sinuses which amplify

the sound. This explains why cats unable to vocalize due to injury can still purr. Some reports suggest that the brain controls purrs and that a repetitive neural oscillator sends messages to the laryngeal muscles, causing them to twitch at a rate of 25 to 150 vibrations per second. This causes the vocal cords to separate when the cat inhales and exhales, producing a purr.

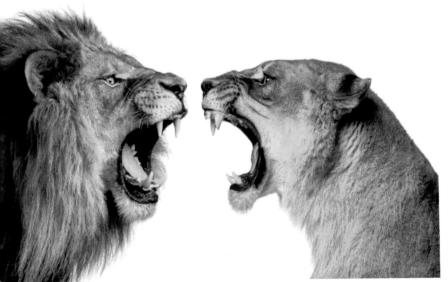

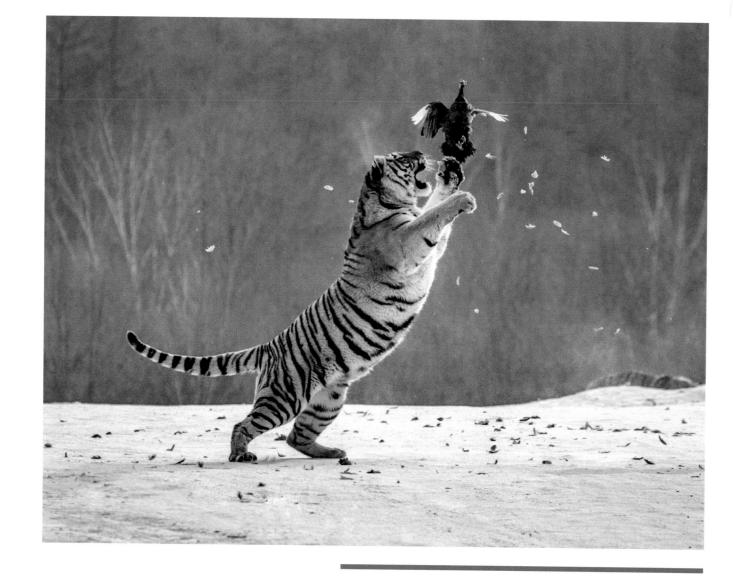

This tiger leaps up to knock birds out of the air, a hunting technique shared with small cats.

MAN-EATERS!

Ider tigers, lions, and leopards will often opt for easy prey, like domestic cattle, when they are unable to obtain game prey because of lost energy, lost teeth, or injury. In some areas, man-eaters become a problem. Lions and tigers eat people only when there's nothing better—and almost anything else is better.

Leopards, however, will kill anything that moves and frequently develop a taste for human flesh. They have been known to attack entire villages when on the rampage. There are certainly times when the ferocity of a riled house cat rivals the man-eaters of India; in these instances, we can be grateful our cats aren't the right size to attempt it.

TIGER

The Siberian tiger is the largest of all cats; it can grow to over twelve feet long (3.7 m), including the tail. There is great size disparity between kinds of tigers, but coloration always consists of either striped shadings of orange, black and white, or rarer black-on-white varieties. Tigers look as though they've been colored with broad bold strokes by a child's crayon.

Aside from their distinctive coats, lions and tigers physically look very much alike. However, their personalities are quite different. Lions avoid the water; tigers enjoy swimming. Tigers are much more agile and aggressive than lions and kill not only for food but for the thrill of killing. They also have been described as more devious than lions. Tigers are mainly nocturnal and are generally solitary hungers.

Most domestic cats detest getting their fur wet, and it is a patient kitty indeed that submits to a bath. Of course, there are always exceptions to the rule; the Turkish Van loves the water. Close the door if you don't want this water baby joining your bath.

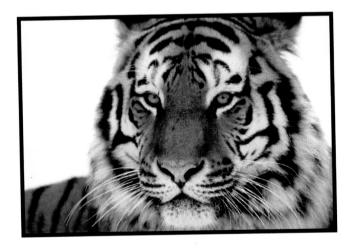

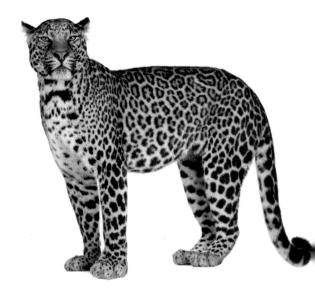

LEOPARD

The leopard is an elegant-looking cat. It has a distinctive dark pattern of rosettes formed from spots that are scattered across a field of golden fur. Some leopards are black, called "melanistic"; occasionally, the dark rosette pattern will still show through.

Leopards, also called panthers, have proportionally smaller heads than other big cats and aren't as heavy in the body as the lion and tiger. Like the lion, the leopard carries "false eyes"—white spots—on the back of each ear. Leopards grow to over six feet long (2 m), with tail adding another forty-three inches (1m).

Leopards vocalize in a series of grunts, coughs, and grating noises but are usually very quiet. They are strong swimmers, good climbers, and ingenious hunters. Leopards have even been reported to fake seizures to attract the attention of prey, then jump up to eat them.

The house cat's repertoire of starvation wails and moaning threats quickly trains the human owners to "feed me before I DIE!" Such adroit manipulation is as ingenious as anything the leopard has to offer.

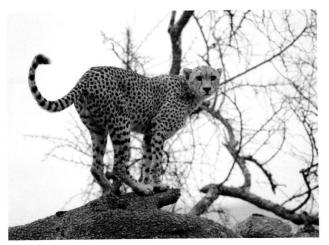

CHEETAH

The cheetah is the only species in the genus *Acinonyx* and is anatomically different from all other Felidae. It is the oddest of all felines, halfway between a dog and a cat.

The cheetah wears dark spots on a light field of gold. It is large but slim and has very long legs with a disproportionately small head. Most members of the cat family have fully retractable front claws, but the adult cheetah's narrow paws and toe structure are more like a dog's than a cat's. The nonretractable claws are blunt and worn down, never razor-sharp like other cats. Because of these anatomical differences, the cheetah has a more difficult time climbing than some of the other cats.

The cheetah can run fast in bursts of speed up to sixty miles (96 km) per hour over short distances, and it is the fastest land mammal. Since ancient times, cheetahs have been domesticated and used as hunters and retrievers in Asia and Egypt. Domesticated cheetahs are said to show faithfulness, obedience, and affection

toward their masters.

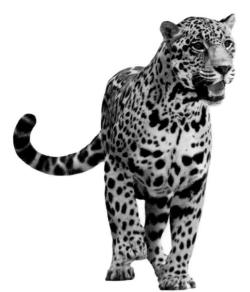

JAGUAR

The jaguar is the only *Panthera* indigenous to North America, but it has been exterminated in the U.S., Mexico, and much of Central America. It can grow to six feet (2m) long, with an additional thirty-inch (75cm) tail. A bristly golden coat is dotted with brown or black spots, or rosettes with dots inside. The coat can also be solid black, like the leopard's. Jaguars climb well, like to swim, and often fish.

Most domestic cats share the jaguar's taste for fish. Many, however, prefer eating their fish straight from a can; they mustn't risk getting a paw wet pulling a fish from the water.

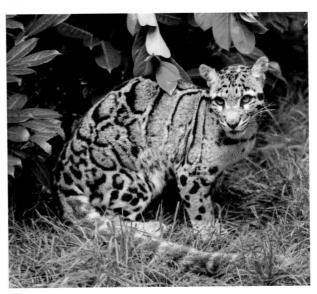

CLOUDED LEOPARD

The clouded leopard is placed by most authorities in its own genus, *Neofelis nebulosa*. It has unique brown-black markings marbled over a light gold field. It is about the size of a small leopard but has a longer body and shorter legs ending in very broad paws. The clouded leopard also has an extremely long tail, and the head is exceptionally large for its body size. It has the largest canine teeth of any other living cat and in this respect most closely resembles the now extinct saber-toothed cats of antiquity.

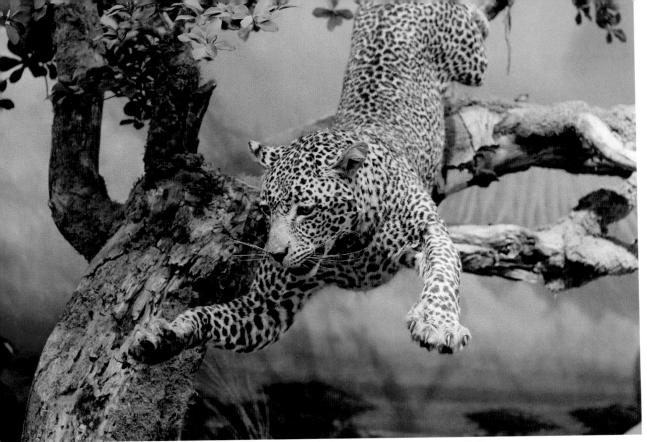

HUNTING TACTICS

he cat's specialization of eyes, claws, and teeth make it ideal for stalk and ambush, like the leopard, above. Most cats are solitary hunters, and many are nocturnal, using concealment and stealth to draw close and pull down prey after a brief, intense rush. Claws hold the prey for the killing bite to the back of the neck, and strong

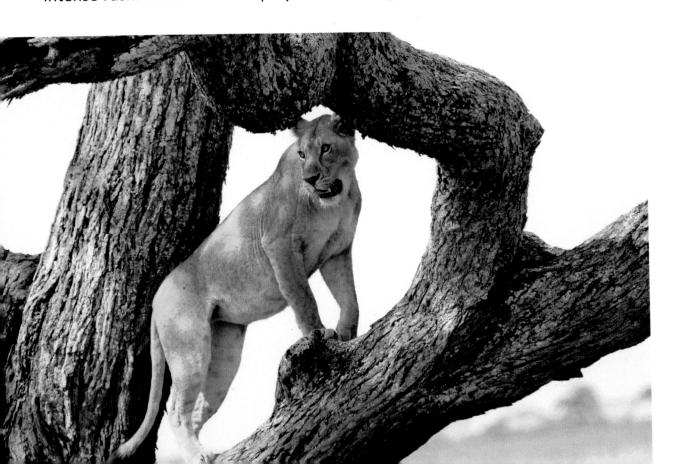

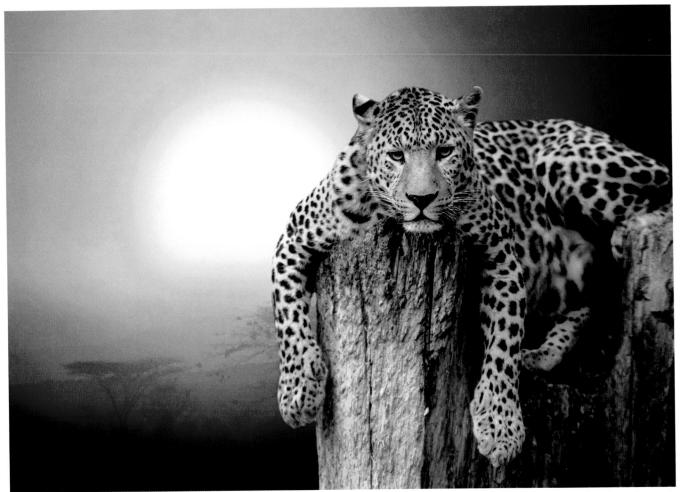

canine teeth sever the spinal cord in an efficient deathblow used by the lion (below) and housecats.

The cheetah is the only cat to "course" its prey, acting more like a wolf than a cat; it often hunts during the day when it can use its eyes to advantage. The cheetah's coup de grace is a bite to the throat, a strangling kill rather than the perhaps more swift and merciful back-of-theneck, spine-severing death stroke of other cats.

All cats are extraordinary athletes, and in addition to being fast, a house cat can jump, on average, up to five times its own height. Leopards (above) also like heights. Some wildcats, such as the

desert lynx, can catch birds by jumping high into the air and knocking them down with their paws.

KITTY FINGERPRINT

Big cats have fur that extends all the way down the nose, while in smaller cats (our pets included), the end of the bridge of the nose is exposed. The ridged pattern of a cat's nose leather is like a fingerprint; each is different. Whisker-spot patterns are also as individual as fingerprints.

SMALL CATS

The genus *Felis* contains a huge variety of species and subspecies. The following represents only a few that are either very similar to, or very different from, domestic cats.

The flat-headed cat doesn't look very much like a cat at all. It has very short legs, a long body, and a short tail with a slightly flattened head. Like the cheetah, it has claws that aren't fully retractable. This cat is among four species (flat-headed, rusty-spotted, fishing, and leopard cats) considered by scientist to be closest to the ancient common ancestor of the whole cat race.

The rusty-spotted cat is smaller than the domestic cat and is indigenous to southern Sri Lanka and India. In

Sri Lanka, it lives in humid mountainous forest, but in India it is found more often in open, grassy country. Agouti gray fur on the head, back, and tail are marked with rusty red spots, blotches, and lines. The underside of its body is white, with large spots. This kitty is easily tamed if taken from the wild as a tiny kitten—but not much is known about its habits.

The fishing cat has slightly webbed paws, with claws that can't be fully retracted. It likes water and has been observed diving to catch fish. The leopard cat is also a fisher and a swimmer and has thus been able to colonize small islands. The leopard cat is unusual in that the males may help raise the young kittens. In most cat societies, the task is left to the female.

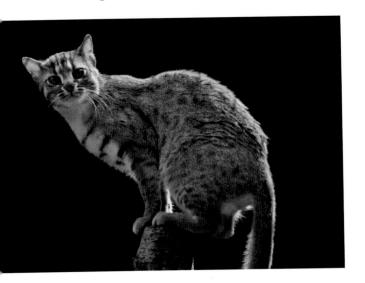

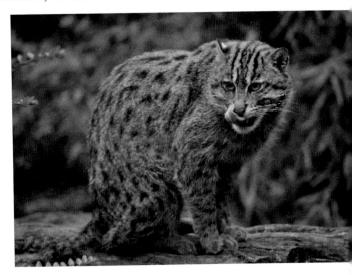

Rusty-Spotted Cat (left), and Fishing Cat (right).

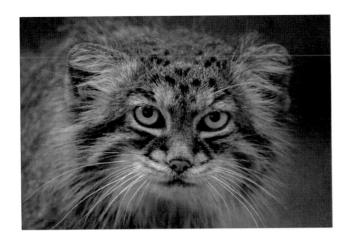

The Pallas's cat, or manul, is an unusual-looking feline with almond-shaped eyes set in a short, broad, slightly flattened head. It has a long ruff of fur on the cheeks, large, low-set, widely spaced ears, and a massive body with very stout legs. The Pallas's cat is about the same size as a large domestic cat. It produces a scream that sounds like a cross between a screech owl's cry and a dog's bark, but it can't spit or hiss like domestic cats. Speculation that the Pallas's cat was an ancestor of the Persian and Angora breeds is today considered unlikely.

The lynx is the only existing member of the cat family found in both the Old World and the New World, and it ranges over Scandinavia to Siberia, Kashmir, and Tibet; Alaska and Canada to the northern United States; Spain and Portugal; and it has been reintroduced in Switzerland and eastern Europe. It is a sturdy cat with rear legs that are longer than the front legs, big paws, and a short tail. It has long tufts on its ears and its fur ranges in color from sandy gray to tawny red.

"I've met many thinkers and many cats, but the wisdom of cats is infinitely superior."

Hippolyte Taine

Wildcats have a larger body and slightly smaller brain than domestic kitties and breed only once yearly. Some scientists have divided the wildcat group into up to twenty-three subspecies. Of these, the African wildcat is considered the most like our own domestic breeds and is probably the "founding father" of the cat that is even now warming on your hearth.

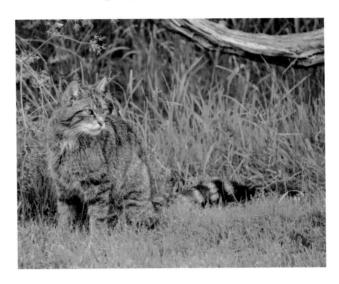

Big cats, small cats, cats with long hair, cats with no hair, spotted cats, striped cats, dark cats, bright cats—no matter what the package, it's obvious that the nation of cats has no boundaries; cats are recognized as cats the world over. Domestic kitties have traveled quite a distance form their wild origins—or have they?

Pallas Cat (above, left), Scottish Wildcat (above right).

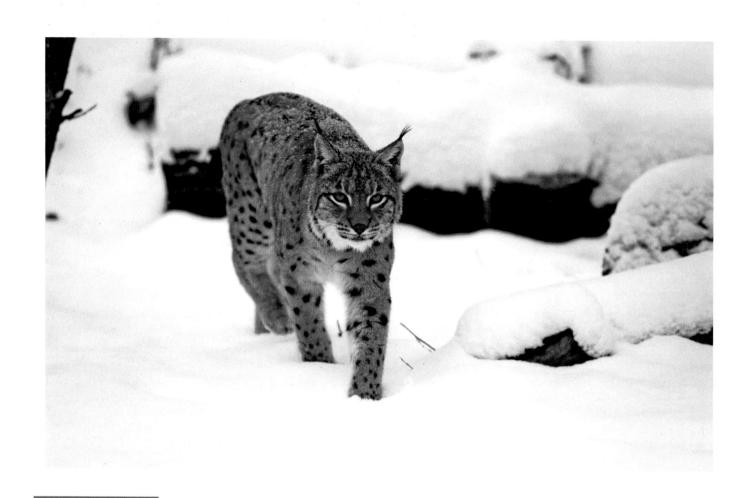

Lynx coat color varies between individuals.

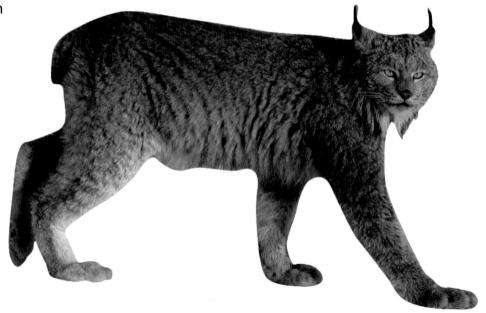

SPECIES LIST

Genus PANTHERA

Jaguar, *P. onca*Lion, *P. leo*Leopard, *P. pardus*Snow Leopard, *P. uncia*Tiger, *P. tigris*

Genus NEOFELIS

Clouded leopard, N. nebulosi

Genus ACINONYX

Cheetah, A. jubatus

Genus FELIS

African golden cat, F. aurata Asian golden cat, F. temminchki Bay cat, F. badia Blackfooted cat, F. nigripes Bobcat, F. rufus Caracal, F. caracal Chinese desert cat, F. bieti Cougar, F. concolor Fishing cat, F. viverrinus Flat-headed cat, F. planiceps Geoffroy's cat, F. geoffroyi Iriomote cat, F. iriomotensis Junglecat, F. chaus Kodkid, F. guigna Leopard cat, F. bengalensis Lynx, F. lynx Marbled cat, F. marmorata Margay, F. wiedi Mountain cat, F. jacobita Ocelot, F. pardalis Pallas's cat, F. manual Pampas cat, F. colocolo Rusty-spotted cat, F. rubiginosus Sand cat, F. margarita Serval, F. serval Tiger cat, F. tigrinus Wildcat, F. silvestris (23 subspecies)

Margay (top),
Caracal
(middle),
Ocelot
(bottom)

THE NAMING OF THE CAT

here is no real way to tell why our feline friends were named as they are, but there do seem to be three distinct origins: names derived from the sounds the cat makes; names based on the action of the cat; and names associated with ancient cat-linked

deities. In fact, words for "cat" are very similar the world over. It's likely these words originated with the very first domesticated kitties and have changed little, if any, over the centuries.

Egyptians named the cat *mau*, which signifies "the seer" (from mau, "to see"). Perhaps this was because they associated it with the all-seeing Eye of Horus.

Other historians speculated that mau was inspired by the mewing sound that the cat makes. Along those same lines, China's word for cat is *miu*—awfully close to meow, too.

Puss seems a natural derivation of Posht or Pasht, which were names used for Bast, ancient Egypt's catheaded god. Others speculate that puss evolved from the Latin words pusus and pusa, which mean "little boy" and "little girl", respectively. How many of us today affectionately call our cats by similar terms of endearment? Another whimsy connects the French le puss to the Latin lepus, which means "hare." This connection is not at all

"CAT"

AROUND THE WORLD

Arabic—kittah Armenian—gatz Basque—catua Chinese—miu Cornish—kath Egyptian—mait or mau French—chat German—katze, katti or ket Greek—kata or catta Italian—gatto Latin—felis or cattus Old English—gattus Polish—kot or gatto Portuguese—gato Russian—kots or koshka Spanish—gato Turkish—kedi

farfetched—"puss" was used in England for both cats and hares well into the eighteenth century.

The Romans called the cat *felis* from the root word *felix*, meaning "a good and auspicious omen" linked to magical divination. Later, they began using *catta*, the same name as the weasel, as both cats and weasels were used as vermin catchers.

Other words may stem from an Aryan root word *ghad*, which means "to grasp or catch." This seems a natural descriptive choice; our cats are experts at seizing prey—or affectionately hugging our necks.

Welsh-kath

HISTORY OF THE CAT

People have been intrigued by the cat since time immemorial. In prehistoric times, humans and cats not only competed as hunters but probably hunted each other as well. Humans have always admired the hunting prowess of cats. Cave drawings of lions in prehistoric art can't be totally explained but point to probable cult relationships. Cat amulets indicate that feline cults have existed since at least Egypt's sixth dynasty. Even a slate palette used for mixing cosmetics dating to 3100 B.C. was embellished with stylized lions.

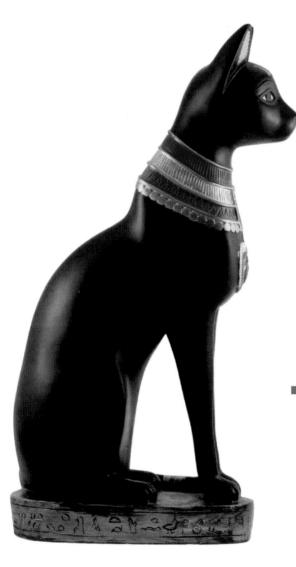

Later, anthropomorphizing became quite common, and ancient civilizations began mixing the best attributes of humans and animals to invent magnificent mythic beings. One of the most outstanding examples is the famous Sphinx at Giza, outside Cairo, which represents Chephren with a human face and the body and power of a lion.

The lion, the leopard, and eventually the cat joined the bull as major symbols of power and virility in ancient Egypt. Mesopotamian cultures so glorified the cat that it eventually outshone all other anthropomorphic figures. Even today, cats continue to be the universal symbol of the side of nature that cannot be tamed.

FELINE BEAUTY

he eyes of the African wildcat are rimmed with a dark lining; during the period around 950 B.C. when cats were considered deities, fine Egyptian ladies often lined their own eyes with cosmetics to resemble these cats' eyes. Cleopatra's famous beauty was said to be enhanced by her extraordinary resemblance to the cat.

This cat with decorative collar is typical of the feline figures associated with the cat cult of Bast; such statues were often presented by worshipers as votive offerings. Bast, considered a goddess of fertility, was usually shown as a cat-headed woman: the domestic cat was perhaps even then known for its sexuality.

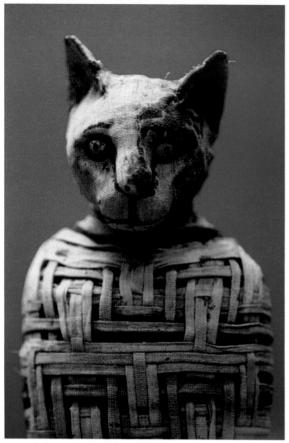

FELINE SACRIFICE

Surviving mummies examined by X-rays reveal that many cats died at ages of less than eighteen months, half were under four months old, and in many cases their necks had been deliberately broken. Despite laws said to have protected cats in Egypt, some cats were bred specifically to be offerings.

Sextus Empericus recorded that in ancient Egypt, where the cat was the symbol of the sun-god, many cats were sacrificed to Horus, the rising sun. In a mystical sense, the deity the cat symbolized died for his people when the cat was immolated.

Mummification for cats wasn't involved as it was for humans, but only wealthy owners could afford elaborate treatment. These cats were treated with sodium carbonate and sodium bicarbonate (natron) to preserve and dehydrate the body. Then they were wrapped in a linen sheet, followed by careful bandaging. The outer cover was cloth or papyrus and palm leaves woven into a pattern molded to shape kitty ears and features. The head was sometimes painted with eyes, nose and mouth. Cat mummies were placed in pottery jars, cases, or funerary boxes, often designed in a cat shape.

THE CAT ON A PEDESTAL

While historians continue to argue about and postulate exactly when the cat became domesticated, it remains entirely possible that the cat domesticated herself. As humans became cultivators, their precious grain stores drew vermin—which in turn called the cat. It seems quite plausible that wild cats so drawn to villages and homes were tolerated and later encouraged to stay and catch mice. How many of us have had a cat adopt us

when she simply appeared one day at the back door and appropriated our home as her own?

The first documents relating to the history of the cat's domestication date from Egypt 1668 B.C. Later paintings of cats found in Theban tombs (about 1450 B.C.) show cats collared and tied to chairs in homes. Cats probably did not share a life of luxury early on, however, but had to earn their keep. Some early

paintings seem to indicate that cats may have been used as flushers and retrievers of game.

About 950 B.C., a city of the Nile delta called Bubastis worshiped a cat-headed goddess called Bast, or Pasht. She was the favorite of the sun-god, Ra, and was associated with happiness, pleasure, dancing, and the warmth of the sun.

The cat was much admired by early Egyptians for mystical qualities. The name "Bast" implies "the tearer" or "the render," exemplified by Bast's nightly battle with the sun's mortal enemy, Serpent of Darkness. Bast was symbolized by the moon, which was believed to be the sun-god's eye during the night; the pupil of the cat's eye waxes and wanes, just like the moon. Even today, the unexpected, eerie glow reflected from a cat's eyes on a dark night is enough to shiver the soul. It's easy to see why Egyptians believed cats held the light of the sun in their eyes.

Sacred cats were protected by Egyptian law, and their care was an inherited honor passed from father to son. Temple cats were watched by the priests, their every move

interpreted as a message from the goddess Bast. Vows or requests were made to Bast by partially shaving the head of a child (the amount shaved depended on the vow or request), weighing the clippings, and presenting the cat guardian with an equal weight in silver. The guardian would then tender his charge with an appropriate amount of fish and the cat's movements would be interpreted by the priest. The record does not say whether a cat eating the fish was a good sign or a bad one. A finicky cat might have posed quite a dilemma.

The occasion of a cat's death was cause for great mourning. Herodotus (born about 484 B.C.) was one of the first anthropologists and the earliest Egyptologist. His observations of the cats of Egypt are some of the best documentations of early cat history to be found. "If a cat dies in a private house by a natural death, all the inmates of the house shave their eyebrows," he

wrote. He also recorded that dead cats were often mummified and placed in repositories.

Herodotus believed all cats were interred in Bubastis, but excavations uncovered kitty mummies buried in several places. In 1890, over 300,000 mummies (24 tons!) were found buried at Beni Hassan. Unfortunately, this wonderful opportunity to study these first domestic kitties was destroyed when most were ground up and used as fertilizer. The archaeologists of the time apparently were not particularly interested in

Egyptians jealously guarded their sacred cats, treating them like beloved children, and none were allowed to leave Egypt. However, as is often the case with such

"forbidden fruit," the cat became a very attractive and coveted possession in the eyes of outsiders. Ways were found to smuggle the cat out of the country. Although Egyptians religiously sought out and ransomed back as many stolen cats as they could, inevitably some were lost to Egypt forever.

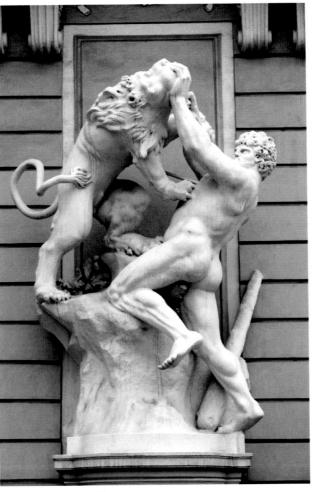

Hercules fighting the Nemean Lion, Hofburg, Vienna.

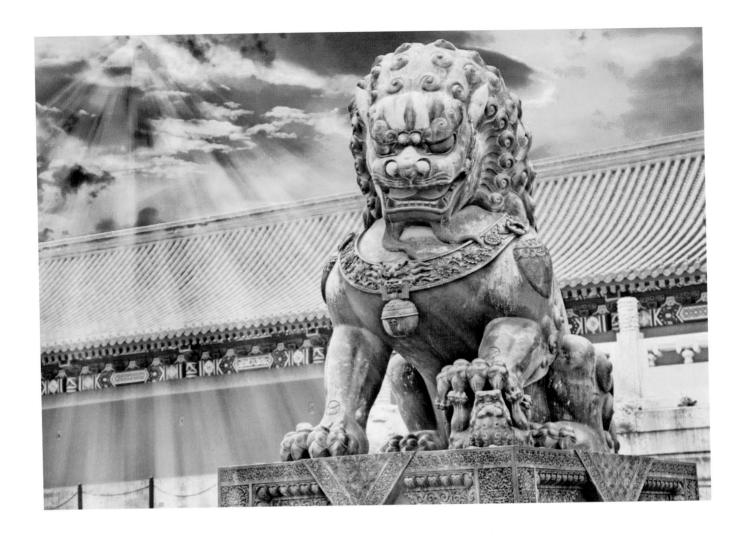

TRAVELING CAT

The domestic cat spread from ancient Egypt to the Orient. In China, the lion and tiger were associated with nobility and good fortune. Oriental mythology is filled with fantastic creatures, including sphinx creatures, which share the attributes of man and beast.

Initially, Persians believed cats to carry disease and gave them no welcome. The earliest confirmed Indian reference dates to about 200 B.C., and some historians speculate that cats most likely reached China later than India and traveled to Japan from China.

However, some references to the cat in the Far East predate the earliest Indian documentation; Confucius is said to have kept a pet cat in 500 B.C. China. One can only assume that a few isolated cats were introduced to China as oddities, not becoming widespread until much later. Toward the end of the sixth century, the cat was associated with the occult in China, but still held a

valued place as a pet with the nobility. These felines shared not only the master's heart and hearth, but also his table, as the main course! Even today, kittens are sometimes sold as a feature of Cantonese cuisine.

Conversely, cats in Japan were much revered, and in A.D. 600 were kept in pagodas to guard precious manuscripts. People of Japan believed that a cat crossing the path constituted good luck. The cat in ancient Japan was considered so precious that during the tenth century, and for several centuries thereafter, Japan restricted cat ownership to members of nobility.

The cat next traveled to Europe. The first stop was Greece, followed by Rome, but kitty was not particularly well known in the ancient Greco-Roman civilizations. However, the few that knew cats cherished them; a woman found entombed in the lava at Pompeii was still holding her pet cat in her arms.

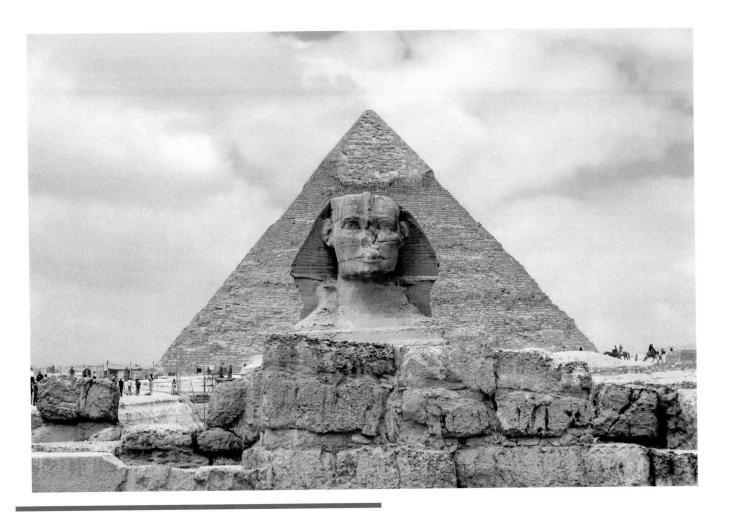

The Sphinx at Giza, outside Cairo, Egypt.

Aesop, a Greek author who died in 546 B.C., wrote several fables in which cats figured prominently. Five hundred years later, Palladius of Rome began recommending cats for protection from vermin. Romans had often kept animals, such as ferrets and even snakes, to keep down rats.

The cat spread from the Mediterranean to the far corners of the Roman Empire and beyond. Kitty was probably not bred and distributed like cattle and other domestic animals but instead distributed herself by traveling with people from place to place.

The cat appears to have been quite rare in northern Europe, even after being introduced there around the tenth century. We probably have the lowly mouse to thank for kitty being where he is today. House mice and rats weren't originally European but were brought back from the Middle East by the Crusaders. Seamen took cats along on ships to control this pest, and consequently the cat spread far and wide.

By the tenth century, domestic cats had arrived in England. They remained quite rare, however, and were highly prized as protectors of grain. A mid-tenth century Welsh King named Hywel Dda set laws specifying the value of cats, including stiff fines for anyone who killed an adult cat. The value of a cat, and the fine for killing one, was double if the cat was a rat killer.

RELIGION & THE CAT

The early church knew about the link between cats and pagan religions. Rather than fight old beliefs and risk dissent, Christianity absorbed elements of the religions it replaced; St. Agatha of the second century was said to take the form of an angry cat to chastise women who worked on her saint's day. Very often the cat is found in pictures of the holy family, representing the "good cat" created to offset the creation of the devil's "evil mouse." Even the Virgin Mary was associated with the cat as the symbol of motherhood. An old Italian legend says a cat gave birth in the stable at the same moment as Mary. Early Christianity took the concept of the Virgin Mary and incorporated the cat fertility goddess' characteristics of love of children and chastity.

Muslim legend says the cat was born of a bizarre love affair between a beautiful lioness and a monkey

Muslims by all accounts seemed much enamored of cats. In A.D. 600, Muhammad preached with a cat in his arms, and there are several beautiful accounts of the Prophet's affection for the cat. A Muslim riddle asks, "Why do cats drink milk with their eyes closed?" and is answered, "So when asked by Muhammad if they've had any milk, cats can truthfully answer they've not seen any!"

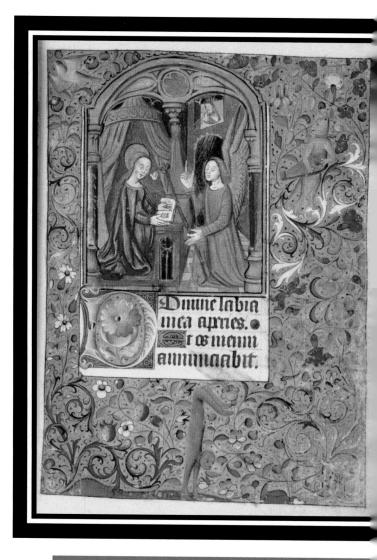

Miniature of Annunciation, with the figure of a monkey and a cat playing musical instruments.

MEDIEVAL LEGEND: Trying to ape God and create a man, the Devil managed to produce only a sorry, skinless animal—the cat. St. Peter felt sorry for the pitiful creature and gave her a fur coat—her one and only valuable possession.

THE CAT'S FALL FROM GRACE

The gods and angels of earlier religions become the demons of later ones. Many churchmen remembered the association of cats with pagan religion, and the "bad cat" became a popular scapegoat when religion sought to eradicate paganism.

Christianity taught its followers to regard the former deities as devils and to regard the followers of cat-gods as evil. The "Judas cat" that sits at the feet of Judas in paintings of the Last Supper is a far cry from the kitten found earlier with the Holy Family. The Church of Europe became the cat's worst enemy and encouraged the cruel ceremonious killings of cats.

During the entire Middle Ages, the cat's favor

continued to fall, until it was reviled 28 treacherous, vile, and untrustworthy animal dedicated only to evil. Although cats were often killed in the name of religion, it was also considered fine sport to torture cats. In Paris, cats in a bag were burned alive each St. John's Day to symbolically destroy evil. Another tradition threw live cats from high places; this went on until after 1817. At her coronation in 1559, Queen Elizabeth I stuffed several cats into a wicker effigy of the Pope, and then burned them.

By the thirteenth century, the Church needed a scapegoat to blame the ills of the world, and it found witchcraft; the cat was an innocent bystander that was also persecuted. Cat were often accused of being the "witche's familiar," and many a sad old woman was killed because of her kindness to a cat. Because alleged witches were usually tortured, the accused persons confessed. That solidified the society's beliefs and confirmed it pursued the right course of action. The hysteria then spread to America, where some of the most infamous practices took place, especially during the heartbreaking witch trials held in Salem, Massachusetts, in 1662.

During the Renaissance, the Catholic Church, by order

of Pope Innocent VIII, decreed the destruction of all cats. Thousands of cats were burned month each England during the Middle Ages. One year, the boy who became King Louis XIII of France persuaded his father King Henry IV to reprieve the burning of animals, but this didn't end practice. Louis XIV was the last king to take part in 1648.

CAT CONTROL

he Church may have inadvertently caused, or at the very least, exacerbated the Great Plague epidemics of Europe. Bubonic plague carried by flea-infested rats killed as many as fifty million people beginning in the fourteenth century in Europe. Disease-infested rats ran rampant because there were too few cats to kill them.

The Old-English name for a tom cat was *gib* or *gibbe-cat* (hard "g"). This term is still used in parts of England and Scotland, and it seems to apply specifically to old, sorry-looking male cats.

BACK ON TOP

By the middle of the seventeenth century, the French began welcoming cats back into polite society. Cardinal Richelieu kept dozens of them at court, and during the early eighteenth century, the French Queen of Louis

XV and her contemporaries made it fashionable to keep pampered felines.

About the same time people welcomed the cat back into hearts and homes, anticruelty societies were organized. British Parliament passed the first anticruelty law in 1822, and the world's first animal protection society formed in 1824. When Queen Victoria became its patron in 1837, it became the Royal Society for the Prevention of Cruelty to Animals (RSPCA). The American SPCA followed in 1866, and ten years later the American Humane Association was founded.

was little more than a friendly gathering of cat fanciers putting their pride-and-joys on display. The first benched show was staged by Mr. Harrison Weir on July 13, 1871, at the Crystal Palace in London. This helped further the popularity of "pedigreed" cats. Showing and developing perfect examples of purebred cats became popular. The first American cat show was held in Madison Square Garden, New York City, in 1895; two hundred cats competed over a four-day period.

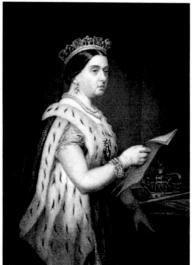

Queen Victoria.

CATS IN WAR

n 525 B.C. the Persian King Cambyses II defeated the Egyptian army by having his soldiers carry living cats as shields before them. The Egyptians refused to risk injuring a sacred cat and offered no resistance.

In 1535, in a report to the Council of One and Twenty at Strasbourg, an artillery officer reported using cats to dispense poisonous gas to the enemy. Poison bottles were strapped to their backs, and the cats were then sent into a panic-stricken run into the enemy camp.

During the siege of Stalingrad (Volgograd) during World War II, a cat named Mourka carried messages from a group of Soviet scouts back to company headquarters.

RECENT HISTORY

It hasn't been until the recent past that cats have been afforded the same veterinary care available to other domestic animals. Previously, cats were treated like "miniature dogs." They were considered by most people to be merely a part of the barnyard menagerie—a self-sufficient little animal that needed little care.

In the early 1970s, cats began to gain in popularity, and a few veterinary practitioners followed the lead of Great Britain, which had become sensitive to cat care during the mid-1950s. Today, feline medicine has surged to the forefront of worldwide veterinary research and has been invaluable as a model for human medical advances.

The mid-1980s saw an explosion in the popularity of cats as pets that continues to this day. Based on the 2017-18 American Pet Products Association survey, the United States cat population today totals more than 94.2 million pet cats.

The U.S. has the greatest number of pet cats, followed by China (almost 87 million) and Russia (22.5 million). There are currently about 8 million cats in Great Britain. Estimates vary from 400 million to 9.8 billion pet cats worldwide.

At long last, the cat has arrived.

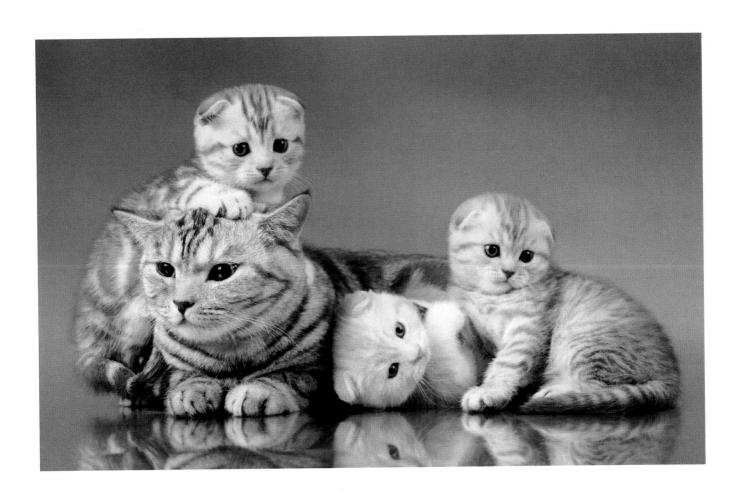

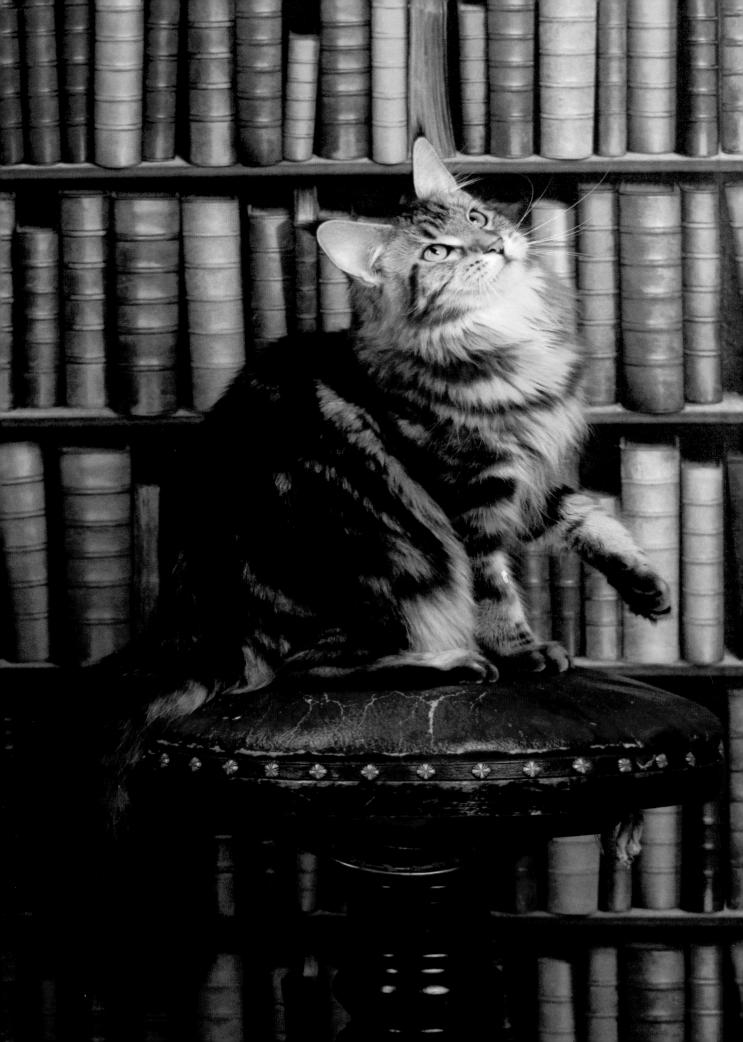

Two:

CULTURED CAT

s for me, I look upon the cat as a poem waiting to happen, its pause mere prologue to prankish delight, its purr a sweet river of song. A cat touches the soul. Wispy whisker-kisses, moist nose bumps—these are gifts beyond measure. To artists, a loving cat is an eternal muse. Writers seem to have an affinity for the feline, and the feeling appears to be mutual.

An early example of cats in literature is a verse by an anonymous ninth-century Irish monk, who worked as a manuscript copyist. He wrote a charming poem comparing the life of Pangur Ban to his own:

TO PANGUR BAN, MY WHITE CAT

I and Pangur Ban my cat

'Tis a like task we are at;

Hunting mice is his delight...

Hunting words I sit all night...

"No favor can win gratitude from a cat."

La Fontaine

One of the first writers to regularly include the cat in his work was the Greek writer Aesop. Later writers, like the English poet William Langland and the French writer La Fontaine, adapted Aesop's fables

as the basis for stories that used the cat to advantage as both a political tool and moral device. Aesop's story "The Bell and the Cat" explores the problem of a domineering cat (the powers that be) playing with mice (common man). A proposed plan to "bell" the cat as an early warning device (kind of an ancient "Star Wars" system) is abandoned when no mouse will volunteer to

place the bell. In "Venus and the Cat," a man is so besotted with his cat that Venus changes her into a beautiful woman. But the woman is unable to deny her true nature and springs from the marriage bed after a mouse and so is immediately turned back into a cat.

Poetry in the form of feline epitaph was a favorite literary form of many writers. A tenth-century Arab poet, Ibn Alalaf Alnaharwany, eulogizes a cat killed because of its habit of raiding the dovecote, bemoaning the fact that had the cat stayed with lesser fare of rats and mice, "thou hadst been living still, poor Puss."

In the nineteenth century, Agnes
Repplier dedicated one of her books to
the memory of her cat, Agrippina. Queen Victoria's
White Heather and Theodore Roosevelt's Tom Quartz
both had biographies written about them.

Cat lovers throughout history have been torn by their love for the cat and their dislike of its enthusiastic war on birds. Benjamin Franklin wrote a very imaginative defense (in feline voice) on behalf of Madame Helvetius's cats to their mistress after the poor cats could not restrain their urge to plunder her birds.

Some stories, although appearing to be but a bit of whimsy, represent historical events. One such story, very old, called "Dick Whittington and his Cat", tells how Dick became Lord Mayor of London all because of a cat. Today, there is a memorial in London on Highgate Hill, called Whittington Stone, where tradition says Dick Whittington heard Bow Bells calling him back to London. Richard Whittington really was Lord Mayor of London—three times (1397, 1406, and 1420)—and a statue of the famous cat sits atop the stone.

Perrault's adaptation of "The Master Cat" fables came about when he interwove characteristics of much older

folk stories to create the famous "Puss in Boots," which first appeared in the 1697 Tales of Mother Goose. The youngest brother inherits Puss, a very clever talking cat. Through a series of ingeniously contrived situations, Puss convinces the king that his master's wealth merits the hand of the king's daughter.

Following the terrible Middle Ages when felines were brutalized, cats slowly became accepted again in England. Anthropomorphizing became the vogue, and by the nineteenth century, the cat was being perceived as a "sly puss," rivaling the fox for his ingeniousness. Moralists and political satirists all took figurative aim at the cat, painting him as a villain or as merely

rascally or stupid.

Later in the nineteenth century, the perception of cats became less stereotyped, and all manner of good, bad, and indifferent cats were represented in literature. This seemed to herald a healthier cat attitude in general.

"I am as melancholy as a gib-cat."
Falstaff (Shakespeare, Henry IV)

A sculpture of Richard (Dick)
Whittington and his cat outside the
Guildhall Art Gallery in London.

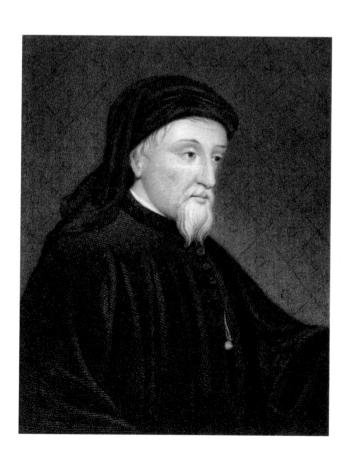

"Lat take a cat, and foster him wel with milk,
And tendre flesh, and make his couche of silk,
An lat him seen a mous go by the wal;
Anon he weyveth milk, and flesh, and al,
And every deyntee that is in that hous,
Swich appetyt hath he to ete a mous."

Chaucer, "The Maunciple's Tale"

Edward Lear's 1871 edition of *Nonsense Songs* included the engaging poem-story of "The Owl and the Pussycat." Folklorists find all kinds of hidden meanings in the nonsense verse, wherein the owl and pussycat (both ancient deity figures) go to sea "in a beautiful peagreen boat" and are married, after which they "dance by the light of the moon." Edward Lear was also the inventor of the Runcible Cat and had a much-loved cat of his own in real life named Foss. Humorous sketches of Foss can be found throughout

Lear's correspondence.

Following Lear's work, a host of stories written especially for children became the vogue. Beatrix Potter wrote and illustrated charming stories about Tom Kitten, Simpkin, and other kitties. Dr. Seuss produced The Cat in the Hat stories that continue to delight children (and adults) today.

Other authors represented the cat in a more serious vein. "The Cat that Walked by Himself' by Rudyard Kipling seeks to explain the very nature of the cat and in effect discounts that any "domestication" has occurred at all. It tells the story of the cat's original bargain made with the first woman. Cat agrees that he may sit inside by the fire and drink milk three times a day if he will kill mice and be kind to babies (if they do not pull his tail too hard). In all other ways, however, he

remains "the Cat that Walks by Himself and all places are alike to him."

Some of the most delightful cat stories are in the form of fairy tales for children. "The Boy Who Drew Cats" is an engaging Japanese tale, in which the cats painted on a screen come alive and slay the ogre, saving the life of the boy who painted them.

Another story set in Japan, "The Cat Who Went to

Heaven," is a touching, uplifting children's tale by Elizabeth Coatsworth that has brought tears to many eyes—child and adult alike. A poor painter can scarce afford to feed himself, yet allows a pretty little cat called Good Fortune into his heart—and through his painting, Good Fortune is blessed and welcomed into heaven by the great Buddha Himself.

Cats inevitably reflected their former associations with the darker side of human nature and the occult. Algernon Blackwood

kept many cats which may have helped inspire his decided gift for writing about the supernatural. Lilian Jackson Braun created the Siamese cat "Madam Phloi" as a recurring character in several mystery stories. A much more ominous and well-known example of the darker side is Edgar Allen Poe's "The Black Cat." Despite the grim tale, Poe was a great admirer of cats, and his tortoiseshell Catarina was a great comfort to

Mark Twain

"One of the most

striking differences

between a cat and a lie

is that a cat has only

nine lives."

him and often slept with his wife to help keep her warm as she lay dying of consumption.

Many other writers were great cat enthusiasts, and often included the cat in their work. Aldous Huxley's recommendation to aspiring psychological novelists was to obtain a pair of cats, preferably Siamese, and observe them. Other famous cat-loving writers included Lord Byron, the Bronte sisters, and William Wordsworth. One cat wrote a book (Paul Gallico was kind enough to translate it from the feline) called *The Silent Miaow*, which is a handbook for cats, not their owners. The book explains how, if you are a cat, you can control literally everything, without humans ever realizing it.

Charles Dickens had a cat called "The Master's Cat," and this engaging kitty would divert the writer's attention by snuffing out the candles with her paw. Mark Twain was a cat enthusiast and shared his house with four cats named Beelzebub, Blatherskit, Apollinaris, and Buffalo Bill. Harriet Beecher Stowe, creator of *Uncle Tom's Cabin*, lived in a house whose property adjoined Twain's. The Stowe and Twain cats often visited back and forth, and even "wrote" letters to each other.

"A home without a cat—and a well-fed, well-petted and properly revered cat—may be a perfect home, perhaps, but how can it prove its title?"

Mark Twain

No discussion of cats in literature would be complete without mention of Lewis Carroll's *Alice in Wonderland*, and the famous grinning Cheshire Cat. The Cheshire Cat expounds on the meaning of insanity, explaining to the dubious Alice that he is truly mad, because contrary to the dog, he growls when he's pleased, and wags his tail when he's angry.

A host of other well-known writers were cat lovers. Ernest Hemingway at one time kept twenty-five cats in his house. He crossed Cuban cats with Angoras to produce what he incorrectly believed to be a new breed

There used to be a kind of cheese made in Cheshire marked with a grinning cat face on one end. Is this where Lewis Carroll's wonderful Cheshire Cat came from?

of cat. Henry James kept cats, and often had one shoulder draped with a favorite feline. The French writer and actress Colette always kept a cat by her side, and she declared "all our best friends are four-footed."

Other cat lovers/writers include May Sinclair, Edith Sitwell, Guy de Maupassant, Victor Hugo, Honore de Balzac, Thomas Carlyle, William Falkner, Damon Runyon, Baudelaire, John Keats, and Vachel Lindsay. All were devotees of the cat, and many wrote charming stories that included their favorite felines.

"The cat in gloves catches no mice."

Benjamin Franklin

COMPOSED CAT

Composers also include the cat in their works, often collaborating with literary cat lovers. Hans Verner Henze wrote an opera based on Balzac's *Loves of an English Cat*, and Igor Stravinsky composed a setting for Lear's "The Owl and the Pussycat."

The distinctive vocalizations of the cat have inspired many composers. Gioacchino Rossini has two female singers compete with variations on the word "meow" in "Duetto Buffo Deii Due Gatti." Another cat duet appears in Ravel's L'Enfant et les Sortileges, for which catlover Colette wrote the libretto. In Prokofiev's Peter and the Wolf, the cat character is easily identified by a clarinet theme throughout the work.

"Cats are a mysterious kind of folk—there is more passing in their minds than we are aware of."

Sir Walter Scott

Even ballet is not immune to the wiles of the cat. Tchaikovsky's *Sleeping Beauty* has a wonderful *pas de deux* for a pair of fairy-tale cats; the orchestration not only imitates their "cat" calls but engineers a realistic feline "spit." But a piece composed truly for and by the cat is "Cat Fugue" by Domenico Scarlatti. The main musical theme was supposedly created by the composer's own cat walking across the piano keys.

Feline themes were not limited to the concert halls, however. The cat leaped into popular music of the eighteenth and nineteenth centuries, and publishers promoted numerous songs with colorful pictures of cats. Many of these songs poke fun at the amorous antics of cats and compared them to humans. "Me-ow Song," a 1919 comedy song by Harry D. Kerr and Mel B. Kaufman, tells of Angora and his evening escapades. Other songs mimicked kitty vocabulary a la Rossini, as in "Cat's Duet" by Berthold, where the only words are "Miau!"

It is appropriate that the cat, with all his foibles, and with society's varying perceptions of him, has long been celebrated in literature. The adaptation of T.S. Eliot's delightful *Old Possum's Book of Practical Cats* into Andrew Lloyd Webber's enormously successful musical *Cats* is indicative of just how far society's opinion has come.

MUSICAL CATS?

Cat lovers and behaviorists agree that cats seem to respond to music—but their explanations remain at odds.

The French writer Theophile Gautier noted that although his kitty enjoyed listening to women singers, she hated high notes, especially high A. She used her paw to try to shut the woman's mouth whenever that particular note sounded.

Another critical cat belongs to flute teacher Sharon Northe. In a letter to a cat magazine, she says if the music is well done, Muffin begs to come into the music room, and basks in the sound of the flute. But whenever Sharon's flute students hit a wrong note, Muffin lets them know. "She puts her foot down—right on the student's foot—and scolds him or her with a commanding chorus of yowls."

Although it's hard to know whether cats listen to music for pleasure's own sake, it does seem clear that many cats are affected by and recognize specific music. The composer Henri Sauguet had a cat that reacted to Debussy's music as if it were catnip, rolling about on

"It is easy to understand why the rabble dislike cats. A cat is beautiful, it suggests ideas of luxury, cleanliness, voluptuous pleasures...etc."

Baudelaire, Intimate Journals

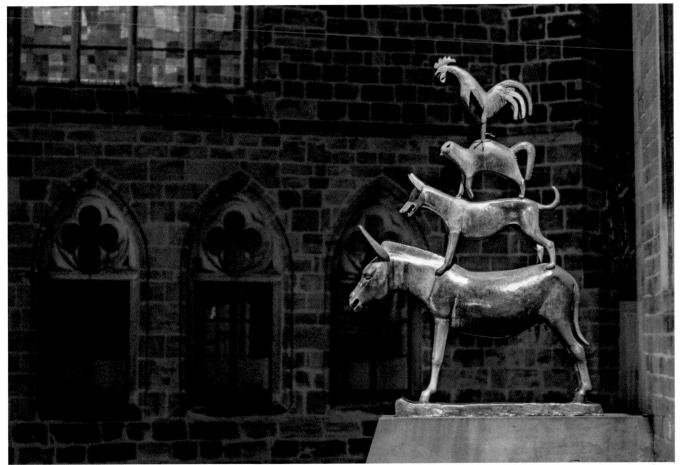

the carpet and licking the hands of whoever happened to be playing the piano. The journal of John Wesley notes that a lion and tiger at the Edinburgh Zoo were fond of flute music.

Some animal behaviorists conclude that cats are merely interpreting the music from their own background knowledge of cat sound signals. Cats, they say, mistake music as the sounds of other cats in distress, or the sounds of parental or sexual behavior, and react accordingly. Because there is such a wide range of reactions—varying from extreme to nothing at all—these specialists label the musical sense of cats as "just another feline myth."

But why shouldn't there be cats that, like humans, appreciate music, while others remain tone-deaf? There

are certainly humans of both types—some are fine musicians, while others couldn't sing "Happy Birthday." Why should cats be different?

Take, for instance, Nora the cat. She became a YouTube sensation when artist/musician owners Burnell Yowl and Betsy Alexander uploaded video of Nora playing the piano. She prefers duets with Alexander's students, but also plays alone, preferring the D-E-F range, and including black keys in her daily compositions. Alexander wrote a piece that includes Nora's compositions, called Fur Release: A Prelude for Paws and Hands.

Many will be disappointed if it ever turns out that feline musical sense really is a myth. If that happens, please, don't tell Nora.

The Bremen Town Musicians (above)—A Grimm fairy tale dating from 1819 in which animals past their prime join forces to become musicians and overcome robbers to live out their days happily ever after. This bronze statue by Gerhard Marcks is in Bremen, Germany.

AILUROPHILE or AILUROPHOBE:

FAMOUS CAT LOVERS AND HATERS

lthough the Church famously persecuted kitty during the Middle Ages, a few individuals later championed the beleaguered feline. Pope Leo XII (1823-29) was very fond of cats and had a large gray and red cat with black stripes called Micetto. He even placed terms in his will providing for the care of Micetto after his death. Another cat shared the dinner table with Pope Pius IX (1846-78). This polite cat, as befitting his owner's station, always waited patiently for the Pope to finish dinner before being served his own food—by the Pontiff himself.

Heads of state also enjoyed the company of cats. Cardinal Wolsey, chancellor of England during King Henry VIII's reign (1509-47), often shared his chair with a favorite cat during important audiences. When President Lincoln found three halffrozen cats while visiting the camp of General Grant during the Civil War, he adopted the forlorn trio on the spot. Winston Churchill and Lenin were both avid cat lovers, and Theodore Roosevelt's cat, Slippers, often attended White House dinners and state occasions. President Calvin Coolidge kept three pet cats, named

Blackie, Tiger, and Timmie—and a canary. Timmie was the ultimate diplomat; he allowed Caruso the canary to parade about on his back. The bird would even snuggle down to sleep between his paws.

Ten Downing Street, the traditional home of the United Kingdom's prime ministers, has had a string of resident cats. Winston Churchill's cat, Nelson, came with him in 1940; Jock was given to Churchill on his eighty-eighth birthday after he had left Ten Downing Street. He was given room and board for life and was even remembered in the great man's will, with the stipulation that a marmalade cat remain in "comfortable residence"

at Churchill's country house at Chartwell forever. Wilberforce, a black and white cat, was chosen from a shelter to be another official Downing Street mouser, and he served under four prime ministers until he was retired by Margaret Thatcher in 1986. Wilberforce died in 1988 at the age of fifteen. The current tabby and white resident, Larry, came from Battersea Dogs and Cats Home. He pulls mouse duty and meets and greets guests.

The famous and notorious have also despised cats.

Hitler hated cats, perhaps because of their historical implications of occult power—power he could not control! Alexander the Great also hated cats. President Eisenhower couldn't abide cats and gave his staff a standing order to shoot cats on sight. Napoleon was terrified of cats; an aide once discovered the great man screaming and hysterically flailing a tapestry with his sword in a frantic attempt to kill the cat he thought hid there.

Why do some people hate or feel terror at the sight of the cat? Certainly, many may be allergic to the

cat or had an unfortunate feline experience. But for each person who endures allergy to keep a cat for love's sake, there are those who experience cold sweats at the mere sight of a cat, with no clear explanation why.

Is the dislike, or fear, due to the cat's innate ability to call his own shots, to refuse to give unquestioning loyalty? Maybe fear springs from the cat's unpredictability or his unsettling aura of "otherworldliness."

For me to understand the reasons for ailurophobia is as hard as explaining why I adore cats. I'm just glad to be on the right side.

The Greek word for ferret, ailouros, has now somehow translated into ailurophile and ailurophobe: an ailurophile is a person who loves cats; an ailurophobe is a person who hates or is afraid of cats.

THE ARTISTIC CAT

People's fascination with cats fostered an early desire to celebrate and commemorate the cat in art. The earliest examples of kitty art appear in cave drawings and ancient amulets used by early cults that worshipped cats. Ancient Egyptian art includes murals found on the walls of ancient tombs, statues representing cat deities, and cat motifs on everyday utensils, clothing, and jewelry. The Brooklyn Museum has one of the best collections of ancient Egyptian art in the world.

Early on, the cat appeared in bestiaries and border decorations of manuscripts. Many of the paintings by Jacopo da Ponte (C. 1510-92) include what appears to be the same cat, which may have been a da Ponte family

pet. Examples of cats as representational art abounded before and during the Middle Ages, when cats were used to represent good and, more often, evil or the devil. In Goya's etching/aquatint *Ensayos* (Trials), the cat familiar is present.

Cats are included in paintings of Christian imagery as well. Albrecht Durer's engraving of Adam and Eve (1504—below left) shows the "good cat" in the foreground ignoring the "evil mouse" because before the fall there were no adversaries. *The Garden of Heavenly Delights* by Hieronymus Bosch (c. 1450-1516) includes Adam and Eve, and a cat stalking off with a rat in its mouth.

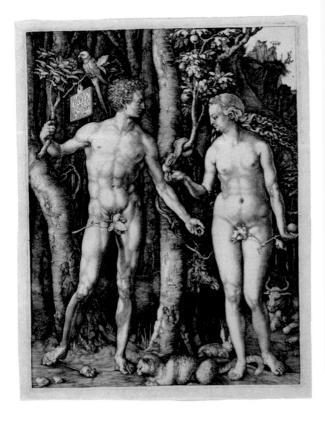

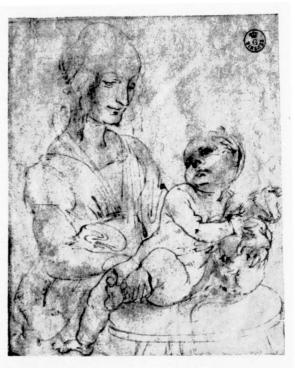

PLATE XCIX. LEONARDO, UFFIZI, 1015.

Paintings of the Holy Family often include a cat. Leonardo da Vinci (1452-1519) painted *Madonna and Child with a Cat*, in which Jesus clutches the kitty to keep it from escaping (a study for the painting on the previous page). Baroccio's painting of "Madonna of the Cat" (now in the national Gallery in London) is linked to the symbolism of the Virgin. However, cats were also symbolically linked to the treachery of Judas, and paintings of the Last Supper often show a cat. Other masters that incorporated the cat in their work were Titian, Rubens, and Rembrandt, to name only a few.

Seventeenth-century engravings more often found cats as companions in portraits. Cats were included in the engravings of both Francis Barlow and Cornelius Visscher. In the eighteenth century, kitties appeared in paintings such as Hogarth's portrait of the Graham children. Another example is the striking and endearing painting by Joseph Wright (1734-97) entitled *Dressing the Kitten*, in which two young girls fit a kitten with doll's clothing.

In the nineteenth century, traveling artists frequently featured cats by themselves or in the company of children. Artist Gottfried Mind became known as "the Raphael of Cats" for his love of cats. He was the first painter to specialize in cat portraits. In 1809, in Basel, the city where Mind lived, there was a guaranted outbrack of which was a first painter of the company of the

suspected outbreak of rabies, and the destruction of all cats was ordered—Mind hid and saved his own beloved cat
Minette but mourned the loss of eight hundred of the city's cats.

Prochainement

Henriette Ronner (1821-1909) also was known for her paintings of cats and kittens. Renoir, Rousseau, Bonnard, Picasso, Dufy, Toulouse-Lautrec, and many other notables included cats in their works.

Swiss-born Theophile Alexandre Steinlen moved to Paris about a hundred years ago and became famous for his graphic renderings of cats. He worked as an illustrator for advertisements, and cats figured prominently in his posters (above right). He would often stop to sketch any cat he saw—his house in Paris became known as "Cat's Corner." Today, reproductions of his work as posters and postcards remain popular.

Madonna with Cat by Romano Wellcome

(Above) Cat and Dog, the altar of the Last Supper in Zagreb cathedral dedicated to the Assumption of Mary.

(Right) The Cobbler of Portsmouth, vintage engraved illustration. Magasin Pittoresque 1870

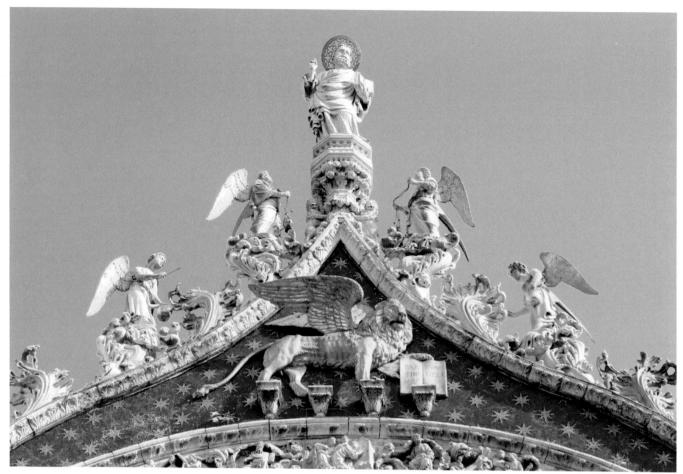

SIGN OF THE CAT

he sign of the cat has always figured prominently in coats of arms. Heraldry used the lion, wildcat, and domestic cat as symbols of ferocity, might, and threat: the British Lion represented Britannia's power; the city of Coventry featured a cat signifying watchfulness; the Dutch chose the cat as their

"God save all here, barrin' the cat."

Old Irish greeting

sign for its love for, and fierce defense of, liberty. The motto of the Mackintosh family is "touch not the cat, but (without) a glove," and its crest is a mountain cat.

Many heraldic signs were chosen as puns and plays on words; hence, the name Archer is represented by three arrows; Butler by tankards of wine; Hunter by Greyhounds. The family crest of the German family Katzen was a silver cat holding a mouse on an azure

field. Most of the old clan of Chatton adopted the mountain cat as their crest. The village sign of Old Catton uses the figure of a cat perched on a barrel, or tun, as it was known to form the rebus "cat + tun = Catton."

Later the cat symbolized evil, and the nobility suspended its use. When Catholicism suffered disfavor during Protestant rule in England, the cat was depicted as sitting at the feet of a Pope to show treason and hypocrisy.

Although scorned by the nobility, the cat's popularity continued among simple shopkeepers and merchants. The Cat in Boots remained a favorite emblem of the bootmakers' guild, and to this day in England, the Cat and the Fiddle appears as a familiar sign for a village inn.

WORKING CATS

Ships cats had their own signal to return to the ship

before they pulled out to sea—the half-hour whistle

called the crew, the fifteen-minute toot alerted

stragglers, and the five-minute trill summoned the cats.

The ships whistles fell silent during World War II, and,

sadly, cats were marooned all over the world.

From the beginning, cats earned their keep sweeping farms and buildings clean of mice and rats. Although cats often "do their duty" as a matter of course, many notable felines have been placed on the payroll.

Newspaper Row famously kept cats. The cats of The Sun, published in New York from 1833 to 1928, were described by their editor Charles Dana, as *Felis domestica; var., journalistica*. At the end of the nineteenth century, The Century Company installed a cat to keep mice from chewing off the backs of magazines. Century, as the cat

was, of course, named, was paid in meals of beef or mutton, and his weekly account audited with the general business of the magazines.

Cats are found in many stables, not only hunting the vermin, but also becoming fast friends

with the horses. Other cats are part of medical "kitty therapy" programs, benefiting human patients immeasurably.

Some cats earn their keep as "enforcers." In the 1990s, the Police Reserve of Grand Prairie, Texas adopted the "biggest, baddest" cat the local shelter could provide—a twenty-pound white longhaired cat called Fang who purred whenever visitors made an appearance, although he was supposed to guard the property room. Another kitty called Donut even had a security badge; he worked as a security cat for Lockheed Shipbuilding Company.

Around the world, cats fulfill duties in churches, libraries, post offices, and hotels. The Cat System of the British Post Office, which began in the autumn of 1868 (and ended in 1984), supported the upkeep of mousers, passing the duties from dad-cat to son-cat. In the 1920s, Billy the stray wandered into the Algonquin Hotel in New York, and a cat has been in residence ever since. Hamlet was a better-known resident of the Algonquin, but the Ragdoll kitty Matilda III, who died in 2017, was probably the best known feline ambassador. An orange

stray cat, also named Hamlet, is the current and $12^{\rm th}$ Algonquin cat and first male serving as ambassador cat in 40 years.

Towser worked as chief mouser on the staff of Scotland's oldest distillery, achieving a world record total "kill" in his lifetime of 28,899 mice. Mike held court at the gates of the British Museum for twenty years, and a 165-page obituary was published upon his death. Dewey, a stray kitten stuffed into Iowa's Spencer Public Library return book slot, was adopted by library director Vicki Myron where he gained nearly a cult

following for the next 19 years. His story, told in Dewey, The Library Cat, became a bestseller

No matter the kitty duties, cats have a knack for

center

taking

stage—some more literally than others. Tanna the Singing Cat was the official greeter at a recording studio in Irving, Texas, and even made her own record. The Bristol Opera House's theater cat Groegheist (Gray Ghost) often disappeared before a performance; the audience was always delighted when he later made his entrance as an unrehearsed, yet totally natural, member of the cast.

Morris, the eccentric spokes-cat for 9-Lives foods, has been an enduring and popular mascot. Discovered in an animal shelter, the original Morris died in 1978. His carefully chosen look-alike successors continue to fill the great cat's famous finicky paws.

Princess Kitty, a former stray turned actress, lived with Karen Payne, her friend and trainer. Princess played Ernest Hemingway's favorite cat in a television miniseries staring Stacy Keach.

Rhubarb (1951) won the first Picture Animal Top Star Award (PATSY) from the American Humane Association. The cats in *Breakfast at Tiffany's* (1962) and Tonto in Harry and Tonto (1985) were also PATSY winners, and the famous finicky Morris won the coveted award in 1973. A gorgeous Chinchilla named Solomon appeared in You Only Live Twice and Diamonds Are Forever, both James Bond movies. The Bond parody movie Austin Powers: International Man of Mystery included Mr. Bigglesworth, a white Angora cat that loses his fur after being frozen and revived—and thereafter appears as a hairless Sphynx, played by cat actor SGC Belfry Ted Nude-Gent. Midnight, the black cat wearing a diamond

studded collar in the introductions to the television series "Mannix" and "Barnaby Jones," won the PATSY in 1974.

Other cat movies achieved great success: In Disney's *The Incredible Journey*, based on a book by Sheila Burnford, a Siamese cat named Tao and two dogs travel two hundred miles to return home; *The Cat from Outer Space*, written by Ted Key, is a sci-fi fantasy about an alien cat named

Jake stranded on earth; *That Darn Cat!* stars a seal point Siamese called D.C. (for Darn Cat) that helps an FBI agent catch a couple of criminals; and *The Three Lives of Thomasina* based on the book by Paul Gallico, featured an orange tabby.

Another orange tabby appeared in *Hunger Games: Mockingjay* as Buttercup, played by a seven-year-old Maine Coon named Orion. Mr. Jinx, the potty-trained kitty in *Meet The Parents* was played by several Himalayan

cats, including a trio named Peanut, Misha and Charlie.

In the Middle Ages, a singed cat was worth less than an unmarked kitty. Buyers felt if kitty lay around in front of the fire, he couldn't be a good mouser.

For most of us, the cat in our life is a star—and we wouldn't think of asking her to work. We know in our heart-of-hearts that our kitty is as talented and beautiful as any of the celebrated cats on the silver screen. It doesn't matter if anyone else ever sees them there—it's enough that they shine for us.

The first television star was Felix the Cat. He was the first image to be experimentally transmitted in the 1920s. Drawn by cartoonist Otto Messmer, Felix is often more notably associated with Pat Sullivan of Paramount Studios, for whom Messmer worked.

Since Felix, many cartoon cats have careened and caterwauled over the airwaves and big screen. They've included such notables as Top Cat; The Cat in the Hat; Tom of Tom & Jerry; Sylvester Puddytat; Jim Davis's Garfield; and all the kitties of Disney's *Oliver and Company* and *Aristocats*. Continuing that tradition, *The Secret Life of Pets* (1 and 2) from Universal Pictures also delighted audiences.

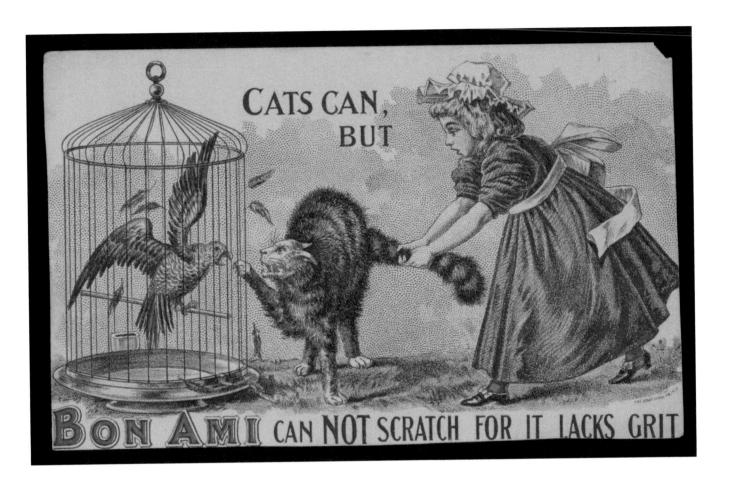

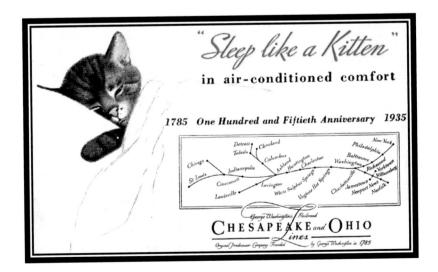

Cats have appeared in advertising for over 100 years, selling everything from Kaliko Kat Shoes to Tabby Cigars and Bon Ami polish (above).

The Chesapeake and Ohio Railroad promoted its services with the popular Chessie the kitten (left).

The Cat House, in Riga, Latvia

LORE & LEGEND

yth and superstition cloaks cat history with mystery. Our ancestors searched for answers to the questions of the existence of the cat and often came up with entertaining and eloquent explanations. One such legend gives as good an explanation as any of the creation of the cat.

Hebrew folklore says cats didn't exist before the Flood. Noah felt very concerned there might be trouble between the lion and the other creatures on the ark, and he prayed to heaven for help. God answered, and sent the lion into a deep, deep slumber. Seeing this, Noah was relieved. But later, Noah became concerned that rats would be as dangerous a problem as the lion—what if they ate all the provisions? Again, Noah begged the Lord to send him a way to fight this calamity, and again, the Lord answered Noah's prayer. The lion, during his slumbers, made a great sneeze—ACHOO! —and out of the sneeze came a pretty little cat.

Creation fables are numerous, as are legends that answer other questions of life. One tells of a contest

between Sun and Moon to see who could create the best animals. Sun created the lion, and the other gods oohed and aahed. Their admiration for the lion filled Moon with envy. In answer, Moon caused a nimble little cat to spring from the earth. But Sun and the other gods laughed at such a poor "imitation lion" and there was much merriment in the heavens. Sun countered Moon's attempt by creating the mouse as a sign of his contempt. In desperation, Moon tried again, and created a monkey; but the monkey received even more hilarity. Moon grew so embarrassed and angered by the mockery her creations aroused, that she caused an eternal a hatred to spring between the creatures. To this day, the lion hates the monkey, and the cat detests the mouse—and all because Sun laughed at Moon.

An early Christian folktale tells how, when the baby Jesus was unable to sleep, the Madonna begged the animals in the stable to help Him to slumber. Sadly, none were successful. Then, a little striped gray kitten padded forward (after first thoroughly licking herself clean) and looked shyly upon the Child. She hopped up and snuggled down beside Him and began to purr a lullaby—and Baby Jesus promptly fell asleep. From that day forward, (so the legend tells), all proper tabby cats wear an "M" on their foreheads, as reminder of the kind service performed for the Madonna.

Muslims include cats in stories about the Prophet. One day as Muhammad meditated, his cat Muezza lay down

on the sleeve of his coat. Because Muhammad stayed very still during his contemplation, Muezza fell asleep. Later, when Muhammad had completed his meditation and prepared to arise, he saw the cat sleeping on his sleeve. Not wishing to disturb the perfect picture of the little cat's slumber, Muhammad took scissors and cut off the sleeve of his coat.

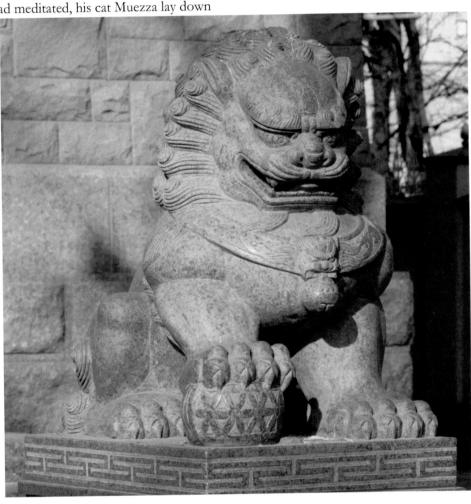

CATS AND GODS

Ancient Egypt wasn't alone in having cat deities. Ireland worshiped a cat-headed god during the first century A.D., and cats are still considered to be conversant with the "little people" (leprechauns) in Ireland. A huge black cat called Iruscan, the King of the Cats, figures in Irish folklore. It was believed that even the proximity of a tortoiseshell cat aided the development of second sight, and children were encouraged to play with them.

Today, it's still an Irish and Scottish belief that tortoiseshell cats bring good fortune.

Freya, the Viking goddess of Love and Beauty, rode in a chariot drawn by the most affectionate of all domestic animals, the cat. Freya was given power over the "ninth world"—some historians speculate this might be an allusion to the nine lives that cats are supposed to have.

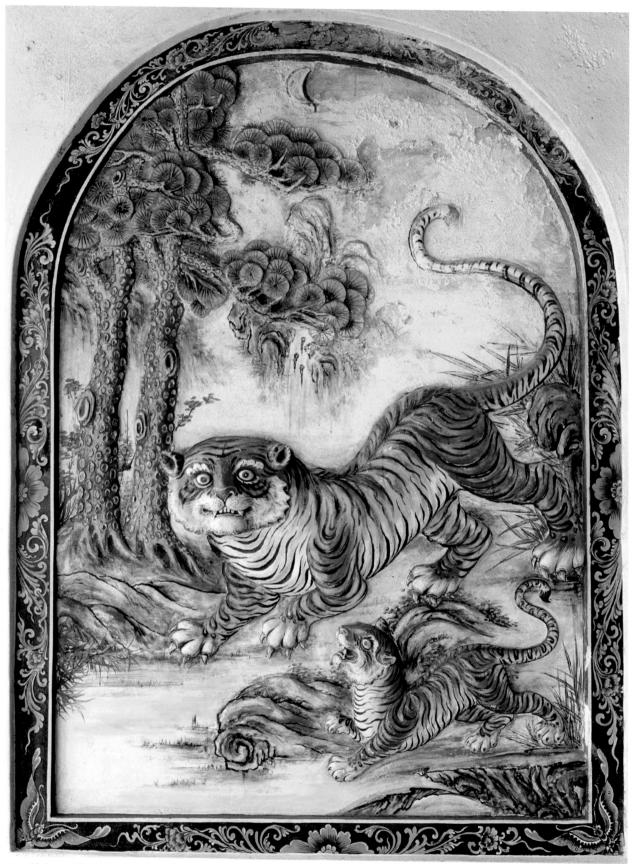

In China, Li Chou was a fertility god worshiped in cat form, to whom sacrifices were offered at the end of harvest. Tigers also figure prominently in Chinese folklore.

Sacrificial cats were not rare; often, the cat would be killed as the last sheaf of corn was reaped. In the Ardennes region of Western Europe, on the first Sunday of Lent, cats were burned, and flocks driven through the smoke as a protection against witchcraft. In Eastern Europe, cats were buried alive in the cornfield

to ensure a good harvest, and people in some parts of France believed that burying a kitten in the garden prevented the growth of weeds. Cats were often included in the foundations or walls of buildings as a charm to prevent rats.

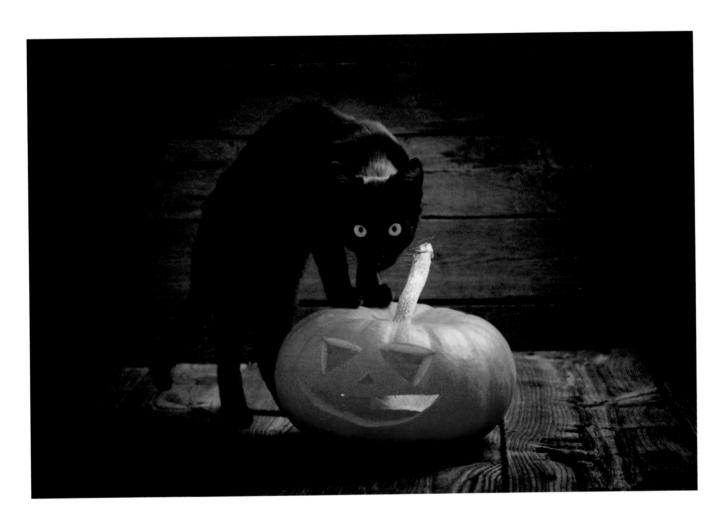

BAD CATS

The cat's padding feet have followed a twisty, torturous trail through history. One of the earliest superstitions affirms that a cat will steal breath from a sleeping child. This fear stems from a belief—probably fostered by Hebrew folklore—that cats were vampires. The Semitic witch-queen Lilith, Adam's first wife, refused to obey Adam and flew away, later becoming a vampire. Lilith can assume the form of a huge black cat named El Broosha, and human newborns are her favorite prey.

Traditionally, a witch's familiar ate by sucking blood from the body—another vampiristic legend. Cats were often thought to be familiars. Witch's cats possessed all sorts of terrible powers; their teeth were venomous, flesh poisonous, their hair would cause suffocation if swallowed, and their breath would infect human lungs with consumption (tuberculosis). Cats made beer go sour and cows run dry and they carried souls to the devil.

Some believed that the witch's familiar was the devil or perhaps an evil "imp" sent by the devil to instruct and inspire the witch. Others held that the witch could assume the shape of any animal she chose, and that the familiar was the witch in cat form. Many believed witches were granted the power to use the body of familiars and could "possess" their cats nine times—yet another allusion to the nine lives of the cat. There is an ancient Celtic belief that kittens born in May should be killed, because they bring snakes into the house.

"May chets bad luck begets

And sure to make dirty cats"

An old Huntingdonshire proverb

In Europe and early America, black cats were particularly feared, because black was the color of the night and darkness, associated with the devil and evil. But before the advent of the witch's familiar, China was the only culture with specific superstition against a black cat. In China, the approach of a black cat was believed to be an omen of sickness or poverty.

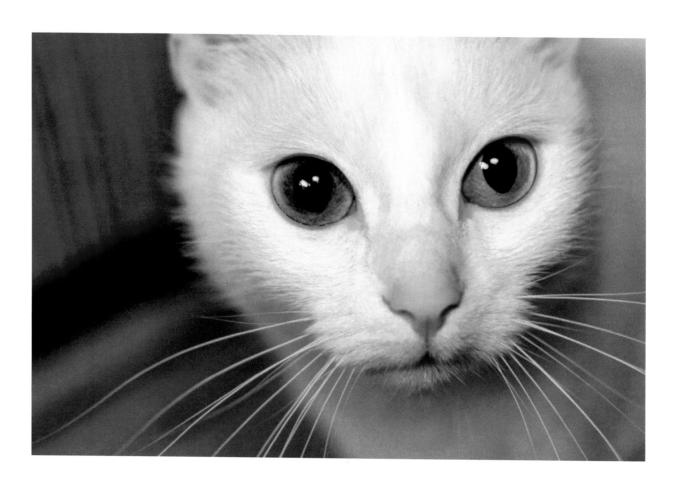

"Odd-eyed" cats are considered lucky. However, congenital deafness sometimes occurs in white cats with blue eyes; this kitty may be deaf on the blue-eyed side.

GOOD CATS

The colors of a cat's fur have sealed his fate, certain shades being more auspicious than others. Sir John Denham, a seventeenth-century poet, supports the color theory in the following verse (probably the terms "fat" and "lean" are used metaphorically to mean "prosperous" or "poor").

"Kiss the black cat, And that'll make ye fat: Kiss ye the white one And that'll make ye lean."

CATS & AFTERLIFE

In Ancient Babylon, it was believed that the cat acted as the host for certain holy human souls after death, for the rest of the cat's natural life; only in this way could the departed soul gain Paradise. The Buddhist, Burmese, and Siamese cultures had similar beliefs. In ancient Japan, certain cats were believed to hold the soul of an ancestor and were jealously guarded as priceless.

CATS & MARRIAGE

Gods of the past were often associated with fertility or virginity, which explains why cats are thought to bring luck in marriage. French folklore says a strange white cat mewing on a doorstep foretells a speedy marriage. In Southern England, owning a black cat ensures the daughters of the house will get married. Other parts of England hold that a black cat is a lucky wedding gift. If a cat sneezes within the bride's hearing on her wedding day or eve, good luck will come to her. But woe betide the maiden that steps on a cat's tail—she won't marry that year.

In a somewhat backhanded "good cat" superstition of the Middle Ages, a cat that crossed your path without doing you harm was very good luck. Britain had a longstanding tradition that a black cat crossing your path or entering your house was good luck. A black cat was also supposed to be able to cure epilepsy.

Old Egyptian tomb inscriptions document the belief that the cat was a bringer of prosperity and health, long life, and beautiful old age. A Buddhist superstition holds that a light-colored cat ensures silver will always be in the house and that a dark-colored cat ensures gold. A tricolor cat supposedly protects a house from fire, and a double-clawed cat is a very potent bringer of good fortune and should be guarded and preserved.

CATS & WEATHER

Cats were believed to have the ability to influence the weather, and particularly storms at sea. A light breeze that ripples the water during a calm, which indicates a coming squall, is still known as a cat's-paw.

Other superstitions state that cats can provoke, rather than predict, changes in the weather. In many countries, bathing a cat or immersing it in water is thought to induce rain. By playing with a string, kitty stirs a tempest, and a playing cat is believed to foretell a gale or to cause it. Scots and Japanese believe tortoiseshell cats can foretell storms. Both countries believe a cat crying in the night indicates a storm. In Scotland, a cat scratching table or chair legs is "raising wind" and a Japanese cat is foretelling rain if it cleans itself behind its ears with a wet forepaw. Because bolts of lightning were designed by angels to rid cats of the evil spirits that infest them during thunderstorms, in Scotland cats are kicked outside to keep the house from being hit.

EXTRASENSORY PERCEPTION

The incredible sensory machine of the cat makes human abilities pale in contrast. Humans, compared to cats, are blind, deaf, and without feeling or scent sense. It must seem to our kitties that their poor upright companions walk around with bags over our heads. Is it any wonder we are both terrified and enchanted by the amazing abilities our cats seem to possess?

Even today, cats cling to their occult reputations of old. Feline behaviorists and other experts remain adamant, though, that cats have no supernatural powers, and that if a cat's unusual action is unexplainable today, it will be scientifically understood tomorrow.

Many superstitions of the past have been explained by today's scientific knowledge. Cats are highly sensitive to vibrations, and often give warning of an imminent earthquake ten to fifteen minutes before it strikes. Peasants who live on Mt. Etna keep cats as early warning devices. Cats also seem able to sense and alert

owners to air raids before the sirens are sounded—again, the vibrations of the planes most likely are felt long before humanly detectable. The association of cats with weather is also quite understandable; we know today that the fine-tuned senses of a cat can detect variation in barometric pressure and that subsequent behavioral changes could predict a shift in the weather.

But, as all cat lovers know, many things about your pet just can't be explained.

PSI-TRAILING

Psi-trailing describes the apparent ability of some cats to find their way home over long distances. This ability is celebrated in the story, The Incredible Journey, by Sheila Burnford, of a Siamese cat named Tao who led furry companions two hundred fifty miles (402 km) across the country to be reunited with their family. One of the best documented cases features a veterinarian's cat, identified by a bone growth on the fourth vertebrae of his tail; the cat left New York and found his owner, who had moved to California. Another cat, Pooh, had a scar on his side and an unusual black spot on his foot; he walked two hundred miles (322 km) four months to rejoin his family, which had moved from Georgia to South Carolina. Chat Beau's owners identified him by the scar on one eye, and his habit of growling like a dog, after he trailed his family to Texas, three hundred miles (483 km) and four months away from Louisiana. Sugar was identified by a deformed left hip joint after arriving in Oklahoma from California—traveling fifteen hundred miles (2,414 km) in fourteen months. Skeptics will never be convinced, but believers cannot be dissuaded of the many instances in which beloved felines somehow turned up to rejoin their families.

WHAT TIME IS IT?

The cat's time sense is also extraordinary. In the past, kitty has mystified man by reliably knowing the time of day specific events occur. To a certain extent we can understand time sense. But what about the cat's ability to know in advance about a change in routine, when

even the human remains unaware? For instance, if your family feline races to the front door thirty seconds before the school bus arrives every day (not at all unusual behavior), how does she know when the bus is early or late? Many skeptics say the cat can identify a bus or a familiar car long before humans are able to, and that this is easily explainable behavior having nothing to do with ESP, but with hearing.

But some cats seem to have this ability when sense of hearing can have nothing to do with the phenomena. The cat Mysouff belonging to the famous French writer Alexandre Dumas was known to be psychic; not only did kitty unerringly meet Dumas at an appointed place and time each afternoon, but if he was going to be late, the cat would know and not bother to leave the house.

GHOSTS & CATS

The belief that cats have a link with the "other world" is widely held. The popular movie *Ghost* features a cat that sees the spirit of the murdered victim, played by Patrick Swayze. "Track the spook," a behavior of watching things that aren't there, lends credence to this belief. The cat fixes his gaze on a point in mid-space between the eye and the nearest object and "watches" the something move—across the room, up the wall, around the ceiling, and out the door. Is it an actual presence, an infinitesimal object, or a sound our own ears cannot detect?

A letter to the *Occult Review* of April 1924 tells of a ghost that appeared in a chair. A cat in the room immediately jumped into the spirit's lap and was dismayed to discover the insubstantial lap would not hold it!

In some instances, it appears that the great love and respect we share with our companion cats lives beyond the grave. There are countless stories of cats wailing at the exact instant of a beloved owner's death or the tracks of never-seen mourning "ghost cats" left at the grave site.

"Some cats won't let a little thing like death separate them from their humans."

Dusty Rainbolt, author of GHOST CATS: Human Encounters with Feline Spirits

GHOST CATS

Spirit-cats often seem to return to beloved owners after death—or at least, a photographable image returns. In 1925, a family portrait taken by Major Allistone in Clarens, Switzerland, revealed a surprise. The photo included a woman restraining a baby from climbing out of its carriage, with an older boy standing in front holding a stuffed rabbit in his left hand. In his right hand, the face of a white kitten appeared—only the kitten had died several weeks before, mauled by a St. Bernard! Examinations of the negative proved the kitten was there. In 1974, a photo taken by Alfred Hollidge in Essex, England, of a live cat name Monet revealed an "extra" catlike form which Monet seems to be watching.

Do our pets really return in ghostly form? Or do our own wishes make it so? Either way, the evidence is extraordinary, and raises eerie questions with no ready answers.

No other creature in history has inspired man to the extent of the mysterious cat. There's no point making fun of people who take comfort in believing these harmless "kitty tales," especially since conclusive proof on either side of the coin is hard to find. Perhaps down the road we'll come to understand such unique experiences, but until that time, such matters are better left undiscussed with those who are so touched by the cat. Someday such phenomena will surely be understood.

But that does not make the cat's mysterious abilities any less extraordinary.

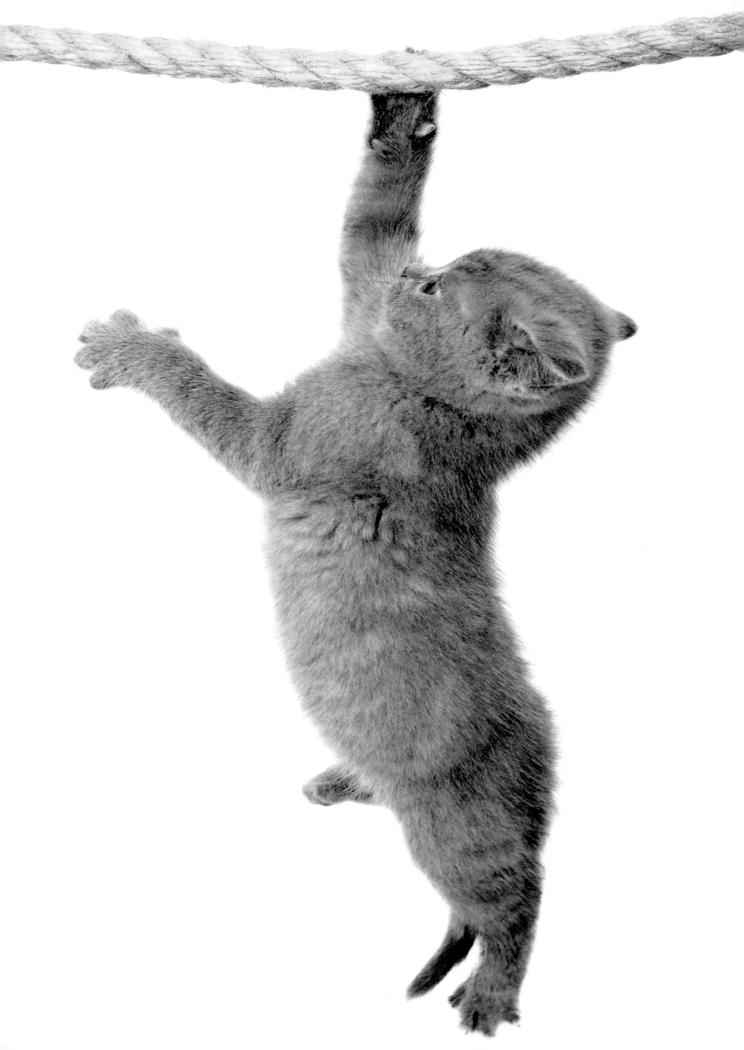

Three: PHYSICAL CAT

THE ACTIVE CAT

cat is a marvel of engineering. Anyone who has ever observed one for any length of time will attest to kitty's amazing flexibility. Cats have very elastic bodies, in part because their spines are held together by muscles instead of ligaments, as in the human body. Cats are so muscular they can move their spines by as much as 180

degrees. A cat has seven cervical, thirteen thoracic, seven lumbar, and three sacral vertebrae—five more than you do. In addition, there are another twenty-one caudal vertebrae in the tails of most cats. A cat's skeleton is made up of approximately 244 bones, which is about one-fifth more in total than humans. The extra bones are mostly in the spine and tail.

Kitty's shoulder blades are on her sides, not the back like a human's. The unique shoulder joints allow the forelegs to turn in nearly any direction and are attached to the chest only by muscles, not by a collarbone. A narrow

In 1950, a four-monthfollowed kitten old climbers to the top of Matterhorn. the highest become the climbing kitty on record. Today, the extraordinary documented at will AdventureCats.org travel the world, go backpacking, sail the seas, scale mountains, and more.

chest and the absence of a collarbone help the cat twist and turn and give her a longer stride in running.

Cats are *digitigrade*; that is, they walk on their toes, which also makes for longer strides. Cats walk with minimum expenditure of energy. They move limbs on each side of the body together, so that the hind feet fall into the

tracks left by the front feet, leaving a single irregular track.

Domestic cats can run about thirty-one miles per hour. The cat's tail acts as a counterbalance, like the pole a tightrope walker uses, and as a counterweight for making quick turns at high speeds.

Cats can dash up trees as fast as they can run on the ground. Most domestic cats are expert climbers, but because of the curve of their claws, many find it easier to go up than to come down. The cat that gets "stuck" up a tree would rather yowl and yodel for human rescue than submit to an extremely undignified tail-first descent.

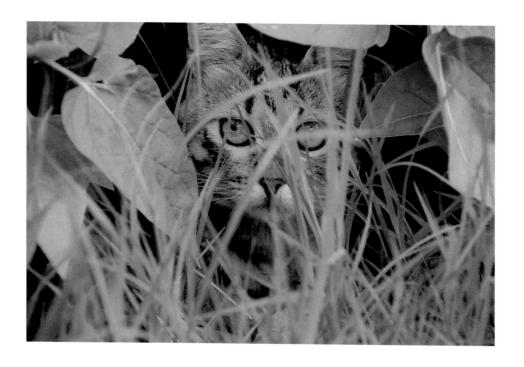

HUNTING INSTINCT

The instinct to hunt is innate in all cats, but the ability must be learned by watching and practice. A cat instinctively recognizes certain "cues" in the hunted animal, such as the indentation of the neck, the texture of feather or fur, and running critters or prey "gone to ground" in a tiny hole. The fur cue is such a significant

one that owners often find their cats "trigger" on furtrimmed coats and chew them to pieces. Other cats may ignore a mouse until it moves. Often, a cat will forego easy prey to "fish" with a paw down a hidey-hole where she has seen a mouse disappear.

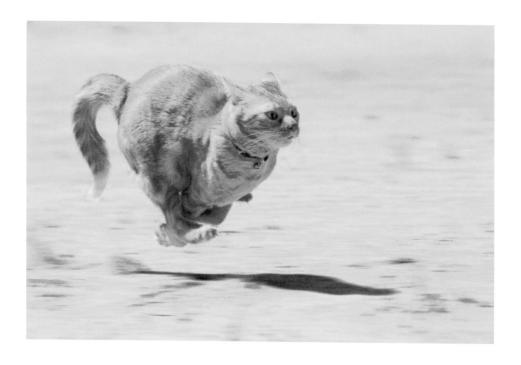

SLEEPING

Cats sleep sixteen hours a day, and seventy percent of that time is spent in light catnaps. During naps, the kitty brain continues recording scents and sounds and comes instantaneously awake when senses trigger an alarm. Only thirty percent of cat sleep is deep. The deep phase includes kitty dreams, where paws and claws twitch, whiskers move, and ears flick.

THE CAT'S EYE

FABLE: At night, cat eyes cast out the light they imbibe during the day, causing a bright shine.

FACT: The night "shine" of cat eyes is caused by the *tapetum lucidum*, a layer of cells backing the retina. The tapetum is like a mirror and increases vision by reflecting light back through the retina. When light escapes, we see "glow-in-the-dark" kitty eyes.

Cat eyes have fascinated us for centuries. Whether gold or blue, green or copper, the beauty and mystery of the feline gaze causes even the most casual cat fan to wonder, "What is it they see?"

As in most carnivores, the feline eye is placed toward the front of the face. This almost doubles the hunter's chances of locating prey by providing a nearly 280degree area of three-dimensional vision. Felidae possess the largest eyes of all carnivores. If human eyes were

LORE: To dream of a living cat's eye is a warning to beware of treachery and deceit.

proportionally the same size as the cat's, they would be approximately eight inches in diameter.

The cat's eyes are positioned in "open orbits." The bony eye socket doesn't form a complete ring around the eye but remains open, to allow greater movement of the jaw.

Domestic cats' eyes use nearly fifty percent more available light than ours do and need only one-sixth the illumination level. A cat sees when light passes through the pupil (black center of the eye) and is focused by the lens behind it onto the retina at the back of the eye. Here, light signals are collected by the rods and cones, or receptors, located on the surface of the retina. Rods respond to light; cones respond to color. Cats have a far greater number of rods than we do. The receptors send signals through the optic nerve to the brain, where sight is interpreted.

The lens of the cat's eye generally doesn't focus nearly as well as the human's. A cat's near vision isn't very good, which is why kitty sometimes has trouble locating food fallen from the bowl. A cat's peripheral vision is clearer than looking straight ahead.

The iris is the beautiful colored portion of the cat's eye that regulates how much light passes through. The iris is a figure-eight muscle mechanism, inflexible along the vertical axis, which spreads (dilates) the pupil sideways to a black circle that seems to engulf the iris, or squeezes it shut to a perpendicular slit. The cat's iris can open wider and shut much tighter than a human's. By constricting in bright sunlight and opening wide in the dark, the iris makes the most of available light.

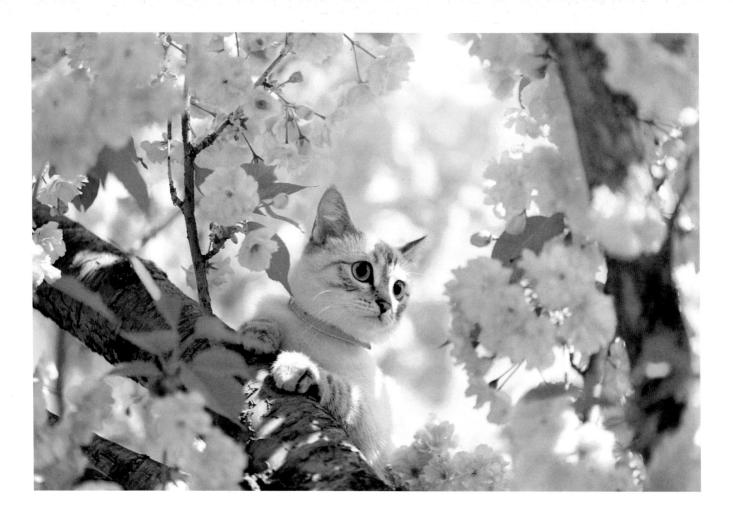

DO CATS SEE IN COLOR?

Yes, cats most definitely see in color; however, they probably don't use or appreciate color the way humans do. Cats see many more shades of gray than we do. Cats are also probably more sensitive to the ultraviolet end of the spectrum, which means they may see colors we can't. Remember that, the next time kitty stares eloquently into space, at . . . nothing?

Although feline eyes have fewer cones (color receptors) than human eyes, cats do have the "equipment" to perceive color. However, until the 1960s, scientists couldn't prove the cat's ability to distinguish colors. Then, studies conducted by R. F. Ewer demonstrated that cats can tell the difference between red and green, red and blue, red and gray, green and blue, green and

gray, blue and gray, yellow and blue, and yellow and gray.

Even so, it takes cats a long time to understand the concept of color. As many as 1,750 experiments were conducted before some cats realized their understanding of color was being tested! Then once they understood the concept, cats had the potential to become color connoisseurs.

Because cats normally don't use color in their day-to-day lives, Ewer speculated kitties literally must "train their brains" to translate color into meaning. This hypothesis led him to conclude that cats can see color—they just don't care about it. Patterns, like tiger stripes, are more important to cats.

Nineteenth-century China told time by the dilation of cat eyes. They believed cat eyes grew narrower until twelve noon when they became like a fine line, and then began to widen again.

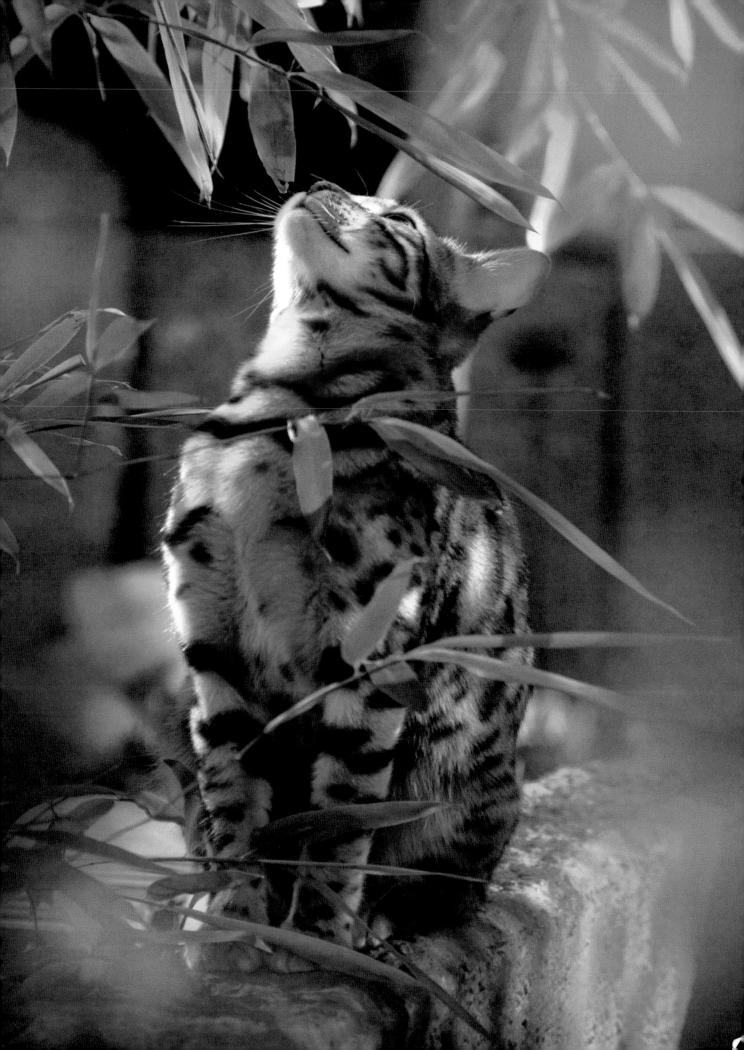

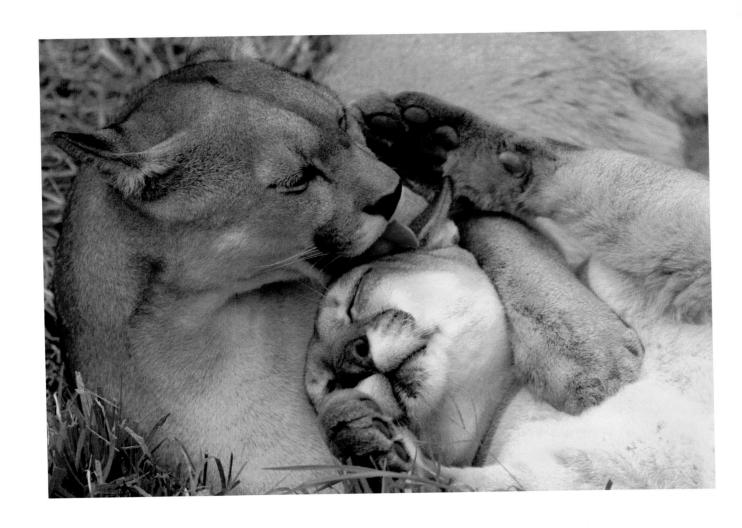

Pumas (above) share grooming just like our house cats. The Snow Leopard (opposite page) can swivel ears 180 degrees.

In the eyes of large to medium-size cats, the pupil is like the human's—circular, contracting to a pinpoint. Pupils of wildcats and most of the genus Felis (including housecats) contract to perpendicular slits. The clouded leopard is unique, midway between the two, with its pupil shutting to an oblong shape.

THE HAW

Cats have a third eyelid called the nictitating membrane, or haw, which is located beneath the two outer eyelids. The haw is pinkish/gray tissue that generally remains lowered in the inside corner. It isn't part of the light control mechanism but serves for added protection and

lubrication. It may move from the inside corner horizontally across to the outside edge of the eye, remaining raised in cats that are not well (a good warning sign of ill health).

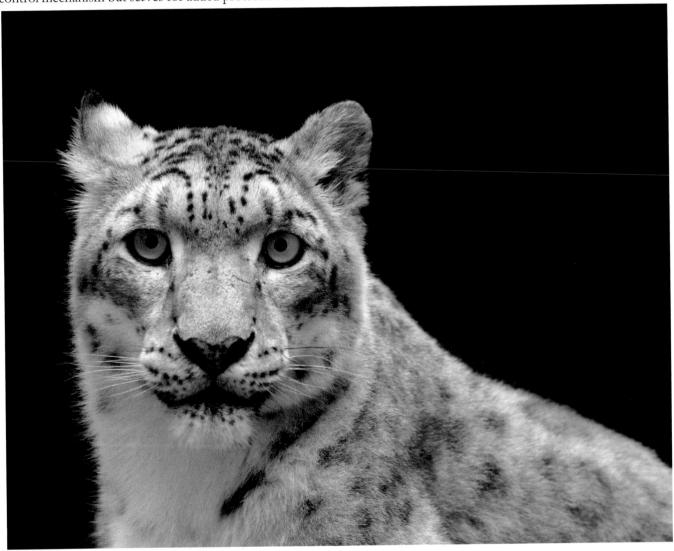

SOUND SENSE

As predators, most cats ambush when they hunt. The cat's greater ability to hear very high pitches at great distances helps pinpoint delicate sounds made by mice or other prey and helps make the cat a superb hunter.

Most cats have large ears that swivel 180 degrees. The movement of the external portion of the ear, called the *pina*, collects and directs sound waves into the auditory canal. Here, the sound waves strike the eardrum, setting

the fragile membrane into sympathetic vibration. This vibration of the eardrum is amplified by the mechanism of the inner ear, composed of a complicated set of tiny bones and fluid-filled tubes. The amplified sound waves are transmitted as signals to the brain, where they are interpreted.

Cats can't hear the low tones that humans can, but they can out-hear us in higher ranges, which may explain why cats respond to higher-pitched voices more readily. Young cats hear better than older ones, and in their prime, cats may hear the higher pitched sounds of mice up to 60,000 cycles per second. (Humans in the best of situations hear only about 20,000 cycles per second.) Precision hearing fades with age. Cats older than five years (still young by most standards) tend to lose this exceptional ability, and thus the edge they had when younger.

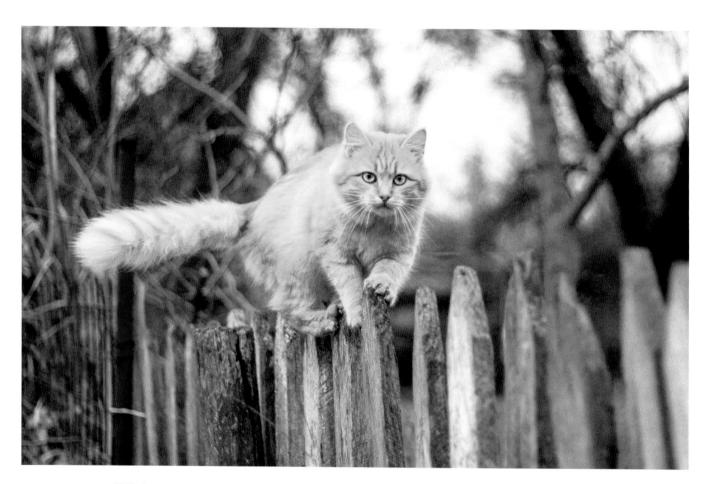

HOW DO CATS LAND ON THEIR FEET?

Cats have an uncanny sense of balance that is intrinsically tied to balance organs (the vestibular apparatus) of the inner ear. These organs provide the cat with split-second information, allowing the cat to instantly distinguish up from down, and to determine acceleration.

This great location sense coupled with the incredible flexibility and muscle control of the spine gives the cat the ability to fall on her feet. The cat determines which direction is up and how fast she is going and with a series of quick contractions of the spine, shoulders, and flanks, simply turns herself in the air.

Cats lacking this inner ear apparatus are still able to land on their feet—but not if they are blindfolded. Therefore, cats probably rely on a combination of eyesight and equilibrium for the falling reflex to function.

When a cat lands, he arches his back and extends his legs to cushion the landing. But a cat can still crack his chin and split his palate—or break his legs. Some falls

(as from the arms of a child) may not give the cat time to right himself.

Falls from greater heights, such as those from balconies and windows of apartments, result in milder injuries. The cats have time to fully relax and "parachute" the body, slowing the velocity of the fall before impact.

SCENT SENSE

If we couldn't enjoy the inviting aroma of a Thanksgiving dinner or the fragrance of a delicate perfume, we would be disappointed but not terribly disgruntled. For us, smell is a source of pleasure, and an important factor in taste. Cats, on the other "paw," rely on an incredible olfactory ability, which is probably more important to a cat than hearing and sight combined.

The cat's nasal cavities are filled with bony plates (turbinals) against which airborne scent particles (chemicals including pheromones) are tested. The turbinals are covered by a thick, spongy membrane (olfactory mucosa) composed of olfactory cells. A human has five to twenty million such cells; a cat has sixty-seven million. Compared to cats, humans are scent-blind. Imagine how frustrating it must be for a cat to sift through colognes, cigarette smoke, and car fumes to enjoy the really important odors—like dinner.

Cats use scent in mating, to recognize food, and to identify friend from foe. Cats also use their scent sense to mark and identify territory. Cats use scent glands in the lips (perioral gland), chin (submental organ), forehead (temporal gland), and tail (caudal gland) by rubbing against objects or other cats in greeting. When Tom winds about your ankles or lovingly rubs cheeks with you, be flattered; he thinks enough of you to mark you as his personal possession. Without that marked

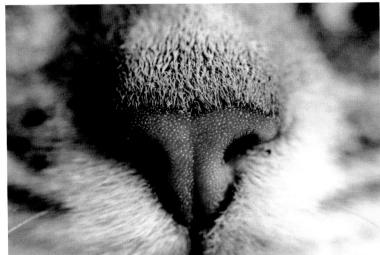

scent, your kitty couldn't tell you from the lady down the street.

Cats have a second scent-detecting organ called the vomero-nasal organ (Jacobson's organ). It's in the roof of the mouth between the nose and the palate. Pheromones, scent chemicals produced by other cats, are transferred to the organ via a tongue flick. You'll see the cat lift his upper lip and wrinkle his nose in a grimacing inhalation, called "flehmen." Jacobson's organ doesn't connect to the olfactory area of the brain. Scientists belief it triggers motivation for feeding and sexual behavior.

Cats often use smell as a means of recreation. Scent identifies life for the cat—without it, he would be lost.

Theophile Gautier's cat, Mme. Theophile, loved the scent of shawls stored in sandalwood boxes. Another named Seraphita "with little spasms of pleasure bit handkerchiefs impregnated with scent."

CATNIP

Catnip, catmint, matatabi (silver vine), *Leriana officialis* (valerian), and cat thyme all seem to drive kitty wild. The scent acts as a nerve stimulant on the brain, lowers kitty inhibitions and promotes relaxation. Seventy percent of catnip oil is *trans,cis nepetalactone*. It's this chemical that affects cats—even big cats. The molecular

structure of *trans,cis* nepetalactone is like that of LSD.

Catnip (Nepeta cataria) is a relative of peppermint and spearmint. Catnip sensitivity is a dominant gene that must be inherited; a third of all cats show no reaction at all, and kittens are not affected.

Catnip often causes an initial burst of energy and

euphoria; then relaxation hits. Cats often sniff and lick or chew, shake their heads, rub their face against the catnip (or other objects), and roll—generally act like engaging, furry fools! Some cats may paw the ground, salivate, or meow incessantly. The effect lasts between five and twenty minutes.

Catnip is not a feline aphrodisiac and will not bring on heat in a female. Rather, drugged cats seem to act out their favorite activity—eating, hunting, playing, mating—but this is just acting. Even neutered animals sometimes imitate mating behavior.

Most experts agree catnip is harmless, but cats may build up a resistance to it. So use catnip treats sparingly, perhaps as a once or twicemonthly treat. The fresher it is, the better the aroma, and the more your kitty will enjoy it. Dried catnip available in pet product stores, but you may wish to

grow your own.

A variety of catnip-stuffed toys are available on the market. Store these in sealed plastic bags to help retain freshness, and they can last three to four years or longer. Be sure to really seal the toy, or kitty will find it—through cupboard doors, boxes, plastic, and all!

EATING AND DRINKING

Because they are carnivores, all cats share a similar dental structure. Most felines have thirty teeth at maturity—kittens and cubs have twenty-six. Cat teeth are designed to grasp and cut rather than chew. A cat turns her head to one side to most effectively use these shearing teeth.

The cat's tongue has rows of hooked, horny, backward-pointing projections (papillae) down its center. They're made of keratin, the same protein found in fur and

claws. The tongue rasps food, and in really big cats, the rough tongue strips meat from the bones of fallen prey. It also acts as a grooming tool for fur and tones circulation—a kitty tongue gives a great massage. Newborn kittens have only a rim of papillae around the edge of the tongue, which helps grasp the mother's nipple. To drink, a cat uses the tip of her tongue to draw liquid upward into a column. She closes her mouth on the liquid before gravity pulls it back to earth.

DO CATS HAVE TASTE?

Smell and taste are very closely linked. Both senses are registered in the same area of the brain. A cat tastes the same sensations people do—sour, bitter, salty, sweet, and meaty/savory (umami), but they're not as sensitive as people's taste buds. We have 9,000 taste buds on our tongues, while cats have only 470. They don't react strongly to sweet but are quite sensitive to fat and meaty flavors. To a cat, taste isn't nearly as important as smell. A kitty with a stopped-up nose often won't want to eat because he can't smell the food.

A cat's taste buds are located on the edges of the tongue and inside the mouth and lips. Cats experience the strongest taste reaction to sour, which can be detected in all areas. Bitter can be detected only at the back of the tongue; salt is at the front. Protein-based chemicals activate kitty taste buds, but animal fats are interpreted as "smells" instead.

Cats remain extremely sensitive to the taste of water; many prefer wet food. The "sandpapery" papillae on the center of the tongue include no taste buds but functions instead to collect fluids.

> Periodontal disease affects nearly all cats over the age of four and can change a cat's perception of taste. Plaque and tartar build up provoke gum inflammation and lost teeth, as well as bad breath. Cats get cavities at or below the gum line rather than in the tooth crown; the pain causes them to stop eating, to salivate, and to show much distress. Use a soft, damp cloth over your finger and massage and clean kitty's teeth weekly, or even more frequently, for healthy teeth and gumsif your cat lets you. Start when she is a kitten and make this a part of a grooming regime. Annual cleaning by your vet is recommended.

Cats love den-like spaces such as snuggle sacks and boxes to lounge, nap, and lurk.

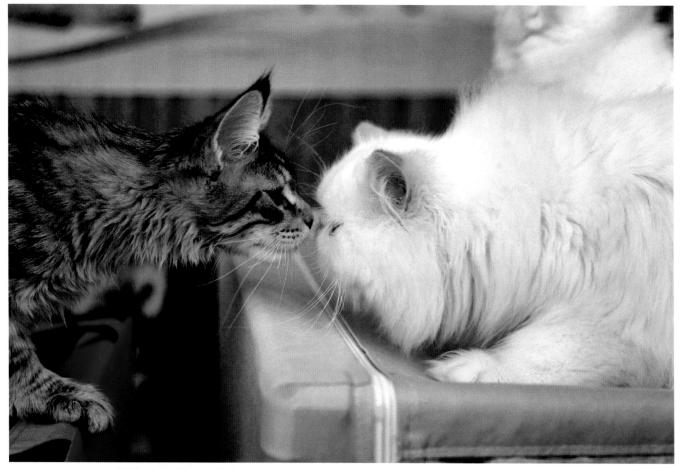

TOUCH

All cats have sweat glands; because cats are almost totally covered in hair, most of the glands are in the pads of their feet. You may notice slightly damp paw prints when your cat feels hot or frightened.

The skin of kitty's neck is five times thicker than on his hind legs, but overall, cats have thinner skin than humans. When human skin contacts feline fur, the result is mutual pleasure.

Paw pads and nose leather are the most sensitive part of a cat's body. Paws are used to test objects. By tapping the sensitive pad against objects, kitty can determine if it is safe or not.

Tiny lumps scattered across the cat's fur-covered skin act as pressure-sensitive pads. Direct contact isn't required; merely brushing hair adjacent to a pad triggers a response. The guard hairs are more sensitive, while whiskers are the most sensitive of all.

Cats identify each other by smell, first engaging in friendly nose bumping, and then anal sniffing. Kitty often tries to do the same with a human, first bumping noses, then turning around to present a tail held high for the obligatory sniff. Even though it insults the cat, most humans decline the invitation.

Cats have highly tactile whiskers (vibrissae), set much deeper in the skin than other hair, that transmit messages swiftly to the brain. Scientists haven't fully explained the whisker function but believe whiskers act something like antennae. They're used to measure openings when a cat enters a narrow space and are also able to "feel" and interpret an incredible amount of

additional information. Whiskers protect the eyes—flick a cat's whiskers, and he blinks in reflex. These stiff hairs are also sensitive to air currents and changes of pressure due to close objects.

Cats enjoy and prefer warmth and can tolerate temperatures to about 126 degrees F/52 degrees C before registering pain. Many a cat will snooze on top of a heater that is too hot for us to touch. Because of insensitivity to heat, a cat may not react immediately if his tail catches fire.

The nose and surrounding skin are the only parts of a cat terribly sensitive to temperature, and here kitty can detect differences of one to two degrees. Cats prefer

their food to be body temperature (about 102 degrees F/38 degrees C), which is why many cats snub food that has been refrigerated.

Touch is a pleasurable sensation important emotionally as well. This is the first sensation he experiences as a kitten when washed by Mom. When a cat (or human) is stroked, the nervous system responds by slowing the heart rate, tense muscles loosen up as the body relaxes, and the increase of digestive juices and saliva flow may enhance digestion. The opposite reactions occur with fear, or deprivation of touch.

Cats enjoy the sensation of being stroked—probably as much as we humans delight in accommodating them.

The cat claiming the highest perch is, quite literally, TOP CAT in that specific area. Vertical space gives cats a safe lookout and lounging place, and may also doubles as a scratching target.

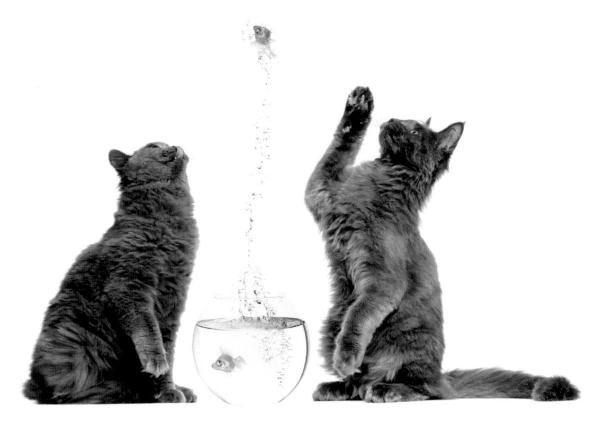

CLAWS

Some cats have one or more extra

toes (polydactylism). This genetically

dominant characteristic gets passed

to offspring. The extra toes make her

look like she's wearing mittens.

A cat's claws are composed of keratin and grow continuously from the last bone of the toe. In a relaxed position, claws are retracted beneath a sheath of skin. When kitty contracts muscles to tighten tendons below the bone, she straightens the toes and extends her claws.

Cats may need nails trimmed to keep them from growing back into the pad. Use human nail clippers or kitty nail trimmers. Gently hold the paw and press to expose the claws. The pink "quick" contains nerves and

blood vessels that should never be cut. The white tips are like our own fingernails and can be trimmed without pain. Trim no closer than one-eighth (three millimeters) inch from the pink portion.

Cats don't scratch to be vindictive or bad; scratching is instinctive, a way

to remove outer sheaths of claws to make room for new growth. Scratching is also good exercise; stretching and digging claws keeps leg, shoulder, and back muscles well-toned. It just feels good to a cat to scratch. Cats scratch to mark territory, too, through both visual and scent marks, and may scratch more when they feel stressed.

Unfortunately, some kitties pick furniture or other inappropriate places to scratch. Punishing cats for this normal behavior doesn't work, though, as cats need a legal outlet to perform this activity. Sadly, many cat owners want to declaw their cats, rather than deal with kitty's natural behavior more positively.

Declawing consists of amputation of the last joint of each kitty toe. This painful, needless surgery may cause further behavior issues when the cat suffers changes in

gait, arthritis, and normal defense mechanisms. Some cats thereafter resort to biting or snub the litter box when painful paws make the litter uncomfortable.

Many cat organizations as well as some countries and

U.S. states now ban the practice as inhumane. A declawed cat can't climb or defend against attack. She can't scratch an itch or groom properly and may experience a change in personality from feeling intimidated. Declawed cats should never be allowed outside, unless on a leash and under supervision.

Instead, let kitty keep her claws and provide legal opportunities for her to scratch proper objects. You must provide a scratching post when you first bring kitty home. Starting right will eliminate many behavior problems before they develop.

Most cats know what to do with a scratching post, but with young kittens, make like a cat and use the post yourself. The sound will alert kitty to what fun you're having. Place the post in a convenient area near the cat bed or food bowl (cats enjoy a good scratch after eating or sleeping). If the post is stuck away in the corner of an empty room, don't expect the cat to hunt it down. She wants her scratch graffiti admired, and so chooses areas near you, like the footstool.

KITTY REPELLENT

Raw onion is extremely unattractive to cats, as is vinegar. Rue (*Ruta graveolens*) is a plant that was used in the first century A.D. to repel the cat, but its oil can burn human skin. There are commercial cat repellents available but check with your veterinarian before using any. Depending on the purpose, the doctor may have much better suggestions.

If kitty already has bad scratching habits, whenever you catch him in the act, firmly say "No!" and take the cat to the post and place (don't force) the paws on it. Praise the cat for scratching proper objects. If you have the right kind of post, kitty should prefer it to the soft sofa. In any case, your pet should soon get the idea of what prompts a "no!" and what prompts praise. Be consistent, and always praise.

The best way to prevent a cat from scratching the wrong objects is to give him something better to scratch. The post should be taller than your cat's full-length stretch, with a sturdy base so the cat can't knock it over. The best scratching posts are covered with sisal, which is a rough hemp product, and can usually be found in pet supply stores. A carpet-covered scratching post may be easy to color coordinate with your room, but most cats prefer rough surfaces that give claws resistance (like plaster walls or wooden chair legs) as opposed to anything else. Watch what types of surface your cat targets and choose a post with a similar surface.

Some scratching posts are quite expensive, and they can even be custom-built; do you think your cat would like

a personal tree, complete with rough bark and perches? Pet product stores are a good place to look or search online sources for a variety of options.

A less expensive alternative (I promise your cat will never know!) is to make your own. Use old carpet samples, wrong side out, to cover a wooden post attached to a solid base. Or, cover a piece of plywood, again with the carpet wrong side out, and mount against a wall. If you have access to firewood, one of the pieces with bark intact may prove irresistible to your cat. Try rubbing the scratch object with catnip—a guaranteed turn-on for many cats.

One of the biggest reasons for scratching in the wrong place is boredom, so remember to spark your cat's interest. Rotate scratching toys and provide choices; you'll have a scratch-happy cat in no time.

If a cat's whiskers are severed, he may lose his equilibrium and stumble into things. Wild felines may lose their hunting and killing techniques.

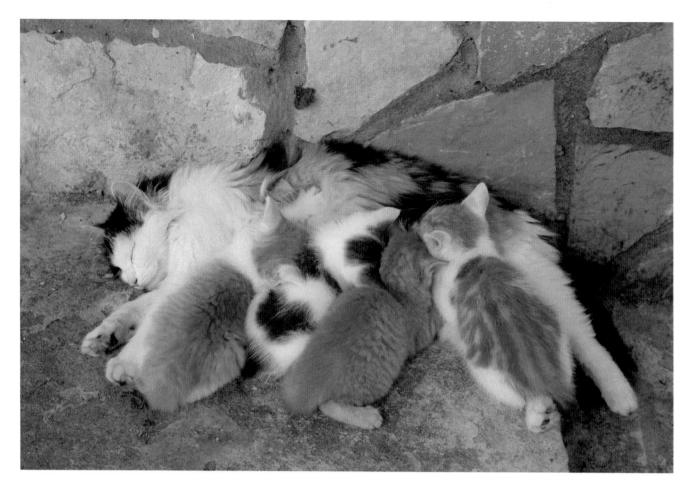

FELINE RESPONSIBILITY

Done Marquis: "what in hell have i done to deserve all these kittens?"

mehitabel

ook at the clock, please. Each hour, thousands of kittens are born in the United States. Each year, more than three million cats are surrendered to animal shelters, and $1/3^{rd}$ of them are euthanized. Some estimate that four million pregnancies would have to be eliminated to prevent the births of twenty million furry babies destined to someday be surrendered or abandoned.

There's no doubt about it. Kittens are cute, cuddly, and endearing. But cat lovers must be aware of their responsibility to prevent, rather than perpetuate, kitten births. With the popularity of cats, it's not surprising

that the number of felines in the United States should be growing. However, cat fanciers realize it's not out of love that population explodes, but rather, ignorance and mismanagement.

With so many throwaway, unloved kittens already available, it's a crime against catdom to breed your kitty—male or female! I can think of no valid excuse to allow any cat to roam and breed. Spayed and neutered pets are better behaved and healthier companions.

Neutering males reduces roaming, fighting (and subsequent wound infections), and spraying to mark

territory. Spayed females no longer experience estrus or associated annoying behavior. Spaying eliminates uterine infection and ovarian cancer, and greatly reduces the incidence of breast cancer.

Responsible breeders support altering, and many require kittens be sterilized when they are adopted. Cat fanciers generally breed only a very few selected felines that are extraordinary examples of a particular breed. Many championship cats that have produced fantastic kittens are spayed and neutered when retired, so they can enjoy life more fully as a pet.

There are more than enough good, responsible breeders; unfortunately, there are even more irresponsible persons allowing cats to breed willy-nilly. If you can't be discouraged from breeding, at least don't be a fool; find a reputable breeder, and study before you start—find out what you're getting into before embarking. Are you prepared to support all the kittens produced for their lifetimes (fifteen-plus years) if they can't be sold?

Think hard—the very lives of your unborn kitties are at stake.

"Be careful of this human love, for it can be more painful than being beaten with a stick. People often stop loving and leave one. We never do."

The feline narrator, from The Silent Miaow

MYTH: "Altered pets get fat and lazy."

TRUTH: Pets get fat and lazy if fed too much without enough exercise.

MYTH: "It's better to have one litter first."

TRUTH: There is no medical evidence that having a litter is good for your pet.

MYTH: "My cat should have kittens; he/she's a purebred."

TRUTH: Twenty-five percent or more of the pets surrendered to shelters each year are purebred.

MYTH: "I can find homes for the litter."

TRUTH: Those homes won't be available for any of the millions of kittens already born.

MYTH: "I want my children to experience the miracle of birth."

TRUTH: You're teaching that kittens are disposable and can be created and discarded as it suits the human. Instead, explain the real miracle is LIFE, and preventing births of some pets saves the lives of others.

A staggering four kittens out of every litter of five are euthanized because there just aren't enough good homes to go around. The kitten you hold on your lap is the lucky fifth. Before you allow a tragedy to continue, look at the clock.

Please.

REPRODUCTION

Some females mature very early and experience heat (estrus) by six months or even earlier. Siamese and other Oriental breeds may go into heat at four months. Kitty will not be shy about letting the whole world know and will vocalize incessantly, calling for "Tom-of-my-dreams." She will luxuriously roll on the floor, rub against you, the sofa, and everything else in sight, and become extremely affectionate.

In arranged breedings, the female travels to the male. After exploratory sniffing and rubbing, she crouches in front of him with her tail to one side and posterior raised and treads the ground. The male gently grabs the back of her neck with his teeth and straddles her, treading with his own rear paws. He inserts his penis into her vagina, and ejaculation occurs after only a few hard thrusts. She cries out and turns on the male, who dodges if he's smart. A cat's ovaries don't release eggs until after copulation, when the tom's spine-covered penis stimulates ovulation upon withdrawal.

The queen experiences no pain with mating. Her screams and postcoital rolling are not fully understood,

but may, in some way, induce necessary hormonal changes.

In about three weeks, if the breeding has been successful, the first clear sign will be an enlarging and pinkening of the nipples. Kitty won't be noticeably swollen until about the fifth or sixth week of pregnancy. Average gestation is sixty-three days. About two weeks before the birth, Mom starts to look for a good place to bear her kittens. Invariably, her choice proves inconvenient for human companions. Typically, this is someplace such as your bed pillow or the back of your closet.

The queen pants and purrs and heads for her chosen nest during the first stage of labor, which may last six hours. The second stage lasts ten to thirty minutes, but no longer than ninety minutes; during this stage, contractions of the abdomen begin, and the mama bears down to expel the kitten. The third stage is the expulsion of the placenta that accompanies each kitten.

About a third of all kittens are born backwards, tail first. Usually this is no problem; kittens are very pliable.

GET HELP IF...

DURING THE BIRTH: Call the vet if your cat's bearing down produces no kittens after ninety minutes (you can see the abdomen clench, and the cat will pant and push and be tensed); if there's a discharge, but no bearing down has been seen; or if labor stops and the queen still carries kittens.

AFTER THE BIRTH: Call for help if the queen bleeds from the vulva; has a colored, white, or foul-smelling discharge; is lethargic; doesn't resume normal eating in twelve hours; is abnormally restless of feverish; or shows no interest in her kittens.

If a kitten is very cold and weak, dunk it up to its neck in a bowl of 101 degrees F (38 degrees C) water (kitten body temperature) for two to three minutes, and stroke and massage it until it becomes more active. Dry with warm towels.

KITTENS

As each kitten is born, the queen breaks the membrane that covers it and licks it to stimulate breathing and circulation. She cuts the cord and often eats the afterbirth. Kittens immediately seek mama's milk; the first milk (colostrum) contains important antibodies and nutrients.

A newborn kitten measures four to six inches long and weighs two to five ounces. It has a flat face, its eyes are closed, its ears are folded back, and it can barely move.

By the second to third day, each kitten claims its "own" teat by smell and nurses from it exclusively.

Feed canned queen's milk to orphan kittens or use for supplemental feedings. Tiny kittens must be fed every two hours. After every feeding, rub the kitten's stomach and anal opening with a warm, damp cloth to stimulate the passage of waste.

The kitten's eyes open at between eight and twenty days. All kittens start out with

blue eyes. Crawling begins about the sixteenth day, and at three weeks, kittens begin using paws to pat things that interest them.

Mom begins weaning around twenty-one days. By this age, kittens naturally imitate her and can eat soupy food from a bowl. They also begin to play and learn the fine art of washing. Mom begins toilet training, and by watching her, kittens learn where to "go" and to bury their waste.

"When I play with my cat, who knows if I am not a pastime to her more than she is to me?"

> Michel Eyquem de Montaigne

At four weeks, kittens begin to demand food, rather than waiting for Mom to ring the dinner bell. By age six to eight weeks, they often leave Mom for new homes. They'll be better adjusted pets if they stay with and learn from Mom and littermates until twelve weeks of age. Other cats are the best teachers of how to inhibit bites and claws.

PLAY

A kitten's brain is almost fully mature by five weeks and has the sensory capability of an adult, but motor development takes longer. Play helps develop motor skills and prepares kittens for life. From four weeks old on, kittens practice technique.

Most cats favor one paw or the other. Twenty percent are left-pawed, forty percent right-pawed, and the rest are ambidextrous.

Four basic actions are learned in play: play fighting, mouse pounce, bird swat, and fish scoop. The first play displayed by kittens is on the back, belly-up, with paws waving. Feints at the back of a sibling's neck mock the prey-bite used later to hunt and dispatch mice. Kittens also practice the simpering sideways walk, back arched high, almost tiptoeing around other kittens or objects. Soon, coordination improves to execute the pounce; the boxer stance; chase and pursuit; horizontal leaps; and, a favorite, the face-off—where kittens enthusiastically bat each other about the head.

On average, a cat's litter consists of one to eight kittens, but a four-year-old Burmese needed a Cesarean to give birth to nineteen kittens in 1970. Fifteen of the litter survived.

CAT TOYS

The absolute worst toy for your cat is your own hand and fingers. This may be cute when kitty is tiny, but an adult cat's bite on tender fingers hurts. Instead, give kitty something to really sink teeth and claws into, without accidentally drawing blood.

Cat-proof your toys. Regulators watch for dangerous children's toys, but there's only you to look out for your cat. The string attached to play mice can be swallowed; plastic eyes and other pieces are equally dangerous. If kitty must have such a toy, pull off removable parts first. Always supervise even the innocuous ball of yarn, which can be deadly if ingested. **Keep kitty away from the sewing basket and thread**; a needle is easily swallowed and requires surgical removal.

The ideal cat toy is very light, easily moved with a casual paw swipe, and soft for teeth and claws to grip. The problem with most toys is they just lie there. After the initial thrill wears off, kitty loses interest. To titillate your cat, give the toy prey-like motion by pulling and pushing it. But remember, it will frustrate your cat if you don't play fair and let kitty catch the prey once in a while.

The all-time favorite cat toy is a small furry or feathered toy on a string attached to a flexible fishing pole-type wand. This fun interactive toy helps exercise cats to keep them in shape, or to slim down a rotund tabby. There are many commercial toys that fit the bill, some with furry mice or feathery bird lures. Cats go absolutely wild turning somersaults, leaping and stalking, as you make the lure flutter through the air or dance beyond her reach as it sweeps across the floor out of paw range. Always put the toy away, though, or your in-house lion will seek it out and destroy the lure.

CHEAP THRILLS

Many cats and kittens create their own entertainment. A paper bag placed on its side makes a great playground for the inventive cat—hide-and-seek, all alone! Ping-Pong balls are light enough for kitty to toss around. Try putting one inside the empty tissue box, or drop it inside the empty bathtub, for the cat to bat around or fish for the object. The cardboard roll from the toilet paper is also loads of fun, and the aluminum foil balls are shiny and make interesting noise.

Just be careful to place breakables out of reach, or kitty will find new games you won't like. Use your imagination; it will keep the kitten in your cat.

RULES OF THE HOUSE

ats aren't stupid—if anything, they're too smart. Cats know that by acting independent (even though they really aren't aloof!), most people won't expect them to obey, and they'll be left alone. Don't let kitty fool you or always give in to what she wants to do. Simply talk, talk, TALK to your cat. Cats can learn a large human vocabulary, and the more kitty understands your words, the fewer misunderstandings and behavioral problems there will be.

Teach your kitten very early the meaning of a solid, authoritative "No!" This should be all that's necessary to correct poor behavior. Never slap or hit your cat, or she will associate your hands with punishment. Punishment doesn't work with cats. Kitty won't understand the connection between the chair she

scratched three hours ago and your anger now. Chasing kitty after scolding makes her afraid of you, and some cats may become defensive and attack. It's much better to make it hard for the cat to misbehave, and instead provide legal options for scratching or other activities.

If you emphasize negatives, kitty learns she gets more attention when she does something wrong. Encourage good behavior. Praise the dickens out of your cat when she does something right—when she plops in the litter pan or scratches the cat tree instead of the new sofa.

Consistency is key. Don't let your cat get away with something one time and disallow it another time. That just confuses the cat. Besides, it isn't fair when you change the rules.

CAT LANGUAGE

Do you speak cat? Felinese is not easy to master; cats communicate with body posture, tail and ear positions and movements, and even the angle of the body in relation to other objects or animals. Cats also respond to verbal cues and scent.

Although we aren't equipped to interpret the finer points, most cat lovers understand a lot more than they think.

A cat's mood can be read by how dilated or narrow the slit of the pupil is and by the position of eyelids. Sudden dilation of the eyes indicates strong emotional arousal. This may be caused by sudden fright, or something as mundane as a hungry cat being presented with a bowl of favorite food.

Slit eyes indicate aggression, as does unblinking stares. If you notice dilated pupils suddenly contract to a slit, it may be kitty has had enough of the toddler and is preparing to strike! Cats with wide-open eyes are generally on the alert; they don't want to miss a thing. Avoid locking eyes with a strange cat—even though you're merely admiring her, she may interpret your

interest as threatening. Half-closed eyes (the sleepy-eyed look) indicates relaxation and trust. Closed eyes are a sure bet kitty is taking a catnap.

Cats also signal mood with their tails. A vertical tail signifies friendly approach. Kittens run to mother, and cats greet owners and each other, with this tail display. When it curves down and up, kitty signals contentment and peaceful pleasure; a slightly curved and raised tail shows interest, and a lowered fluffed tail indicates fear. A quiet tail with only the tip twitching shouts irritation; expect a swipe from a paw! A cat that wags her tail violently from side to side displays agitation and a warning of attack.

Fluffed fur indicates excitement of some kind (fear, threat, arousal, play). Bristled fur on a straight tail means aggression, but a tail arched and bristled shows defensiveness; the cat may attack if further provoked.

Relaxed happy cats keep whiskers extended in the mouth area; if bristly or pulled tight along the face, aggression or fear is the translation.

Body position also offers clues. A confident cat threatens head on, with a direct stare and a body poised to rush and strike. An apprehensive cat arches her back sideways to the adversary, in order to look bigger and more impressive. Cats show submission or surrender by crouching, with ears down, tail tucked, and all four feet under the body.

"A cat can be trusted to purr when she is pleased, which is more than can be said for human beings." William Ralph Inge

PHYSICAL CAT - 86

SAY WHAT?

xperts have identified sixteen different kitty voice patterns classified under four groups: murmur patterns, such as purring and trilling, occur when kitty is in a friendly relaxed state; vowel patterns, like meowing, are used to gain attention; articulated sounds, or chittering, are generally associated with solicitation and frustration; strained intensity sounds, like hissing, growling, and screaming, are used primarily during attack or defense, and in mating.

FEEDING THE CAT

Scarf, snarf, gobble, slurp, gulp, scrounge. No matter how you say it, eating is one of life's oldest, dearest pleasures—according to our cats, that is. Does dinnertime mean confrontation with Morris' Evil Twin? Or is your cat victim of the Garfield Syndrome, a finicky eater that wants only what's on your plate? Does kitty eat to live, or live to eat?

Cats are true carnivores; their intestines, being designed for digestion, meat proportionally shorter than ours. You'll discover kitty loves poultry, fish, eggs, and meat, and it's possible to feed your cat a home prepared ration. A commercial product provides a balanced diet that's easier to prepare. Dry foods don't spoil, but cats often prefer canned foods—and frankly, they're better for kitty. Cats require four times more protein than dogs. Don't feed kitty dog food, or vice versa, or serious problems could result.

Chocolate is toxic to cats—beware of Easter bunnies!

Cats also love milk, yogurt, ice cream, cheese—almost any milk product. However, adult cats have difficulty digesting milk sugar, and diarrhea often results from milk fed to weaned kittens or adults. Small amounts as

a treat are okay if diarrhea is not a problem, but milk should never take the place of water. Cats should be encouraged to drink as much water as possible, to help prevent any urinary disorders.

Is your cat like Garfield, who would subsist on munchies alone if given a choice? Some cats learn to open cabinet doors or even the refrigerator to help themselves. A child-proof lock may be required for determined felines. Be aware that some human foods, like onions, are toxic to cats.

Cats enjoy a variety of people foods. Olives affect some cats like catnip, while other kitties prefer chips and snacks. Eating grass is common and not unhealthy, for it contains vitamins and acts as a natural emetic. Cats also like tomato sauce, and don't be surprised if kitty begs for fruits and vegetables. Melon and corn on the cob are often favorites.

Many cats are creatures of habit that want their bowls to be consistently in the same place. Other cats could care less about location, as long as the bowl stays full. Some kitties prefer privacy and quiet for dining, while a few enjoy the friendly competition of communal feeding.

Bowl type factors in dining. Bowls should be heavy enough that they don't tip over or make the cat "follow" them around the room. Longhaired and flat-faced cats need shallower dishes to keep from dirtying themselves when they eat. Cats also dislike bending their whiskers, so saucer type bowls work best.

Some cats develop allergies to plastic dishes, which are also harder to clean than other types. Ceramic dishes are excellent but should be made in the United States to ensure the glaze is lead-free and safe. Glass doesn't hold odors. Just be careful with chips or cracks. Stainless steel is tops—nearly indestructible, easy to clean, and chip-resistant.

Tuna is high in polyunsaturated fat which cats have trouble metabolizing. It's also highly addictive to cats. Tuna can rob a cat's body of vitamin E, leading to a painful condition called steatitis, or Yellow Fat Disease, in which the skin becomes unbearably tender.

Offering your cat "grazing" opportunities that mimic feline hunting

behavior helps keep cats entertained. Puzzle toys work great for dry kibble or treats, or you can hide several saucers around the house with a few kibbles for your cat to seek out. Cats normally eat several mouse size portions a day, so portion feeding with food dispensers works best.

How cats eat is just as entertaining (and as varied) as what they eat. Some refuse food that falls out of the bowl, while other cats purposely carry bits to the living room rug before they munch. Some cats use their paw to lift food and water into their mouths. Every cat has his own eccentricities. We've all known people whose lives revolve around food; cats aren't so different, if you think about it. My own cat Karma once pulled a dashand-grab maneuver and stole my husband's kabob off his plate. At least Karma has good tastes.

BATHROOM ETIQUETTE

Toxoplasmosis is caused by a

protozoan parasite that spreads

through egg-like oocysts in cat

feces. The disease poses risks to

women should avoid cleaning

litter. Since the oocysts must

incubate several days to spread

the disease, regular daily cleaning

provides the best prevention.

SO

pregnant

unborn babies,

Probably the least pleasant element of living with cats is dealing with kitty's litter-ary needs. Cats are by nature extremely fastidious, clean animals. They won't eliminate where they eat, sleep, or play, and they usually bury their waste. In the wild, this behavior keeps odor from attracting predators to the den.

It's rarely necessary to train a kitten to use the litter box. A kitten follows Mom to the litter pan, digs around,

smells, and soon knows what to do. For the occasional kitten that needs a little extra help, show him the box (right after a meal is best) and scratch the litter with your finger. Kittens tend to get the idea very quickly. Praise the kitty when he makes a proper deposit. Monitoring the box can also help with early diagnosis of health problems.

Placement of kitty's toilet is very important. It must be convenient for the cat to use, but not too close to meal or sleeping areas to

offend the fastidious cat nature. Some cats act very shy and private when it comes to toilet habits, so make sure to locate the litter pan in a private area. Attractive folding screens are available. Some cats like covered boxes for privacy, which also helps contain the litter from enthusiastic diggers. Other cats feel trapped in covered boxes, or dislike the enclosed smells, so let your cat decide what works best.

Standard litter pans, made of easily cleaned plastic, measure about twelve by eighteen inches. Larger pans work better for bigger or standing-pose cats that tend to over-shoot the smaller models. There's a huge variety of pans available in pet product stores, but some cat lovers prefer to make their own from jumbo-size plastic storage boxes. Many cats won't share potties, and a few felines want a different box for urine and feces. The 1+1 rule (one box per cat, plus one) works in many

cases. If you have a single cat or friendly felines who agree to share, one giant-size pan may suffice. Keep a small whisk broom and pan handy to clean up litter tracking, or any "near misses." While litter pan liners are excellent in theory, cat claws and the plastic rarely mix successfully.

Cats seem to prefer clay litter, the finer the better. Clumping products are convenient for people, and

deodorized products smell best for humans but may offend the cat's sensitive nose. A variety of alternative litters now are available, but your cat has the final say in what's acceptable. By staying on top of cleaning, you can easily control most odors.

About a two-inch layer of litter works best. Once you find a litter product that works well and kitty likes, don't change brands unless necessary. Cats don't like change and switching products may prompt your cat to look for a better place to

and swi your cat go to the potty.

Use a slotted spatula or kitty scoop for daily removal of fecal matter; this will extend the life of litter because kitty won't reject the full box. Thoroughly clean the pan and change the litter every few days as needed—sometimes weekly is enough, but oftener may be better. Remember to thoroughly rinse away the odor of the cleanser, too, or kitty may avoid the bathroom—such sensitive noses!

Today, you also can find a variety of "automatic" litter boxes that electronically clean soiled litter. These offer great convenience to people, and many cats accept them once introduced slowly to the idea of the unexpected movement. This should not replace you monitoring and inspecting your cat's "creativity" for any health issues that may be present.

HIT OR MISS

Cats "go" in the wrong places for any number of reasons: not wanting to "share" with another cat, stress, change in family (new baby, marriage, divorce, new pet, loss of pet), dirty box, litter pan too small (perhaps the cover holds bad smells, or a tall cat can't squat comfortably), pan smells wrong, litter too dusty, the location is wrong, etc. Some cats have the best intensions, but their aim sucks. Most importantly, cats break training when they're sick.

Whenever an accident occurs, be sure you know why, so you can act appropriately to prevent recurrence. You may need to enlist the aid of a knowledgeable cat behavior expert to figure out the reason and offer solutions for retraining.

Once kitty starts using a corner of the room, it's hard to break the habit. Clean "accidents" with a commercial odor neutralizer to discourage a repeat accident. If kitty continues to use the spot, discourage it with aluminum foil laid over those areas, or an upside-down plastic carpet protector (with the little nibs up) to shoo him away.

Hard-case cats that habitually leave little presents around the house can be dissuaded by feeding them in those places. Divide normal dinner portions onto paper plates and set them in the notorious spots. Since kitty will avoid voiding where he eats, this should help. Once the cat stops the old habit, return to the preferred feeding spots.

At about six to nine months of age, unaltered male cats begin to spray urine to mark territory. They back up into position, their tail (held vertically) slightly trembles, and they spray urine over the object. Cats won't mark over another's mark, unlike dogs, who pee on everything. Neutering reduces or eliminates urine marking behavior.

CAT CARE

ne of the best ways to choose a veterinarian for your cat is to seek recommendations from other cat owners. All vets will do their best for your kitty, but one doctor's temperament may suit your cat (and you) better than another. Charges vary, so you may wish to shop around. More importantly, choose a veterinarian you can trust. After all, you're dealing with your cat's health.

VETERINARY MEDICINE CONSTANTLY IMPROVES, AND INFORMATION QUICKLY BECOMES OBSOLETE. USE THE FOLLOWING INFORMATION AS A GUIDE ONLY. FIND DETAILED CARE AND BEHAVIOR ADVICE IN THE "FURTHER READING" RESOURCES ON PAGE 131. CONSULT YOUR VETERINARIAN FOR THE MOST CURRENT INFORMATION SPECIFIC TO YOUR KITTY.

VACCINATIONS

Your cat should receive an exam and vaccinations as soon as you get him. To be fully protected, kittens (just like human babies) need a series of booster shots. Typically, the first is given at age six to eight weeks, and additional "boosters" two to three weeks apart thereafter.

Feline rhinotracheitis and calicivirus cause upper respiratory disease in cats, which includes cold-like symptoms (watering eyes and nose), and sometimes mouth or eye sores. The illness can progress into pneumonia. Feline pneumonitis also causes purulent eye and nasal discharge,

with sneezing. Feline panleukopenia (distemper) produces depression, fever, diarrhea, and vomiting, and has a ninety percent mortality rate. Rabies acts on the nervous system and results in paralysis and death. Feline leukemia virus (FeLV) causes a variety of diseases and symptoms, including cancers and immune suppression that makes cats prone to other illnesses. Feline immunodeficiency virus (FIV) also causes immune suppression and makes cats susceptible to early death from other infectious agents. These diseases are devastating, contagious, and preventable with proper vaccinations.

ALTERING

Although cats are often sterilized between six and nine months of age, many shelter and rescue organizations surgically sterilize kittens as early as six to eight weeks old. In any case, kitty is completely anesthetized and feels no discomfort during surgery. Some cats may be sore for a day or two afterwards, while others experience little or no discomfort. Very young kittens seem to bounce back more quickly than older cats.

An *ovariohysterectomy* removes the ovaries and uterus from inside the lower abdomen of the female cat. A small incision is made on her shaved and sterilized tummy, and the Y-shaped organs are tied off and detached. Stitches closing the tummy may be absorbed

on their own or removed in 7-10 days by the veterinarian.

Castration (neutering) is external and less involved than the abdominal spay surgery. After any hair is eliminated, tiny incisions are made in the male's sterilized scrotal sac. The testicles are expressed, drawn out, and removed.

Shelter and rescue adoptions often require sterilization, and many agencies provide certificates for reduced-cost surgeries that veterinarians gladly honor. Check with your local agencies today.

POISON!

Signs of poisoning vary but may include abdominal pain (hunching of the back), diarrhea or vomiting, incoordination or convulsions, or difficulty breathing. Household cleaning products, houseplants, and any insecticides can be dangerous. Antifreeze is deadly; it tastes sweet and causes renal damage and death if not treated in time. If you suspect kitty has been poisoned, call your veterinarian and/or a pet poison control center for specific action.

COMMON PARASITES

The *ear mite* lives on the surface of the skin of the ear and feeds by piercing the skin and sucking lymph. Irritation, inflammation, and black, tarry exudate form inside the ear, making kitty scratch and shake his head. *Mange* is caused by a burrowing skin mite and usually results in itchy lesions on the head and neck. Both kinds of mites are extremely contagious and can be eliminated with proper veterinary treatment.

Ticks are bloodsucking parasites that attach to skin like tiny balloons. They not only cause painful lesions, ticks also carry disease. *Cytauxzoonosis*, a tick-borne protozoan parasite disease, causes a deadly illness in cats.

The *flea* is a highly specialized bloodsucking parasite and the number one complaint of pet owners. One cat can host up to two hundred of the wee beasties. Fleas can cause anemia and allergic reactions (scratching) and transmit disease and *tapeworms*. Both ticks and fleas can be controlled with cat-safe preventive medications.

Cats are extremely sensitive to chemicals, so be very careful with insecticides. Only use veterinary-approved products. You may need to treat the house, yard and your cat by following veterinary and product recommendations.

Cats groom away as many as fifty percent of the fleas on their bodies, and over forty percent of flea-infested cats have *tapeworms* from swallowing infected fleas. Cats also get tapeworms from eating rabbits or rodents, but flea control prevents most tapeworm infestation and

recurrence. Tapeworm segments look like dried grains of rice that stick to the anal area of your cat's fur. An effective and safe drug available from veterinarians eliminates the pest.

Other intestinal parasites affecting cats include hookworms, which suck blood and can be contracted by eating contaminated food. Weight loss and anemia may result. Roundworms live in the stomach or intestines and look like strings of spaghetti when vomited or passed in the stool. Kittens often become infected by swallowing eggs from mother's milk. In large numbers, they can cause intestinal damage and prevent food digestion. Threadworms and whipworms are also common parasites. Intestinal worms can be easily eliminated and prevented with proper veterinary treatments and products.

Heartworms are a blood parasite transmitted by mosquitoes. They enter the bloodstream as larvae, mature, and lodge in the right ventricle or pulmonary artery, and interfere with heart action and blood circulation. Untreated heartworms may cause signs that resemble feline asthma. Ask your veterinarian about preventive treatments.

Several protozoan parasites cause illness in cats. Haemobartonella (hemotrophic mycoplasmas) is a blood parasite that causes anemia and other illnesses. Coccidiosis infects the intestines and causes diarrheal disease, as does Trichomoniasis. These parasites can't be seen with the naked eye, and require specific tests to diagnose, and medications to treat.

WARNING! Over-the-counter pain medicine like Tylenol and aspirin can kill your cat. Even small doses are dangerous. Always consult with your veterinarian before giving your cat any medication.

GROOMING

Grooming removes dead hair and loose dander, reduces shedding, and stimulates and distributes natural oils. Cats love the grooming experience—they get scratched and rubbed and massaged in all their favorite places. If fur is matted or tangled, have a professional groomer show you how to keep the coat in good shape.

Hairballs naturally occur when a cat grooms himself, and swallows fur; the hair is either vomited or passed by defecation. Regular grooming alleviates the problem, and cat laxatives are available to help with elimination. Most cats find hairball medicine very palatable. Petroleum jelly will also help them pass hairballs; kitties often lick off jelly spread on their paws—they love it, and it works as well as many commercial products.

SPECIAL CONCERNS

Because a cat's skin heals so quickly, abscesses often develop when the surface heals, but the deep pocket of infection remains. Most abscesses must be surgically drained and treated by a veterinarian. An abscess looks like a fluctuating tender lump beneath the fur, usually in the cheek/neck area. It can swell to mammoth proportions if not treated. Rupture results in the thickened, scarred jowls and cheeks often found in unaltered toms. Abscesses are painful, and the subsequent infection gives rise to high fevers. Prevent cat fights to avoid wound abscesses. Neutering reduces the urge to squabble.

Acne occurs on the chin, when hair follicles become blocked. It may also arise from a sensitivity or allergy to plastic food bowls. If at the base of the tail, the condition is called *stud tail*. Although stud tail affects both sexes, it seems more common in sexually active male Persians and Siamese.

Diabetes mellitus results when the pancreas fails to produce enough insulin to move glucose into the cells of the body—kitty can't metabolize food. Symptoms include excessive drinking, urination, and appetite, as well as weight loss.

Obesity is often a culprit. Large volumes of fat can alter and suppress production of insulin, which results in a diabetic state. If the cat returns to normal weight, the diabetic state may be reversed. Some cats fed a canned high-protein food go into a remission state.

Without insulin to move glucose into the cells of the body, the body can't use food. Even a well-fed cat with an insulin insufficiency loses weight.

Eventually, the body turns to other food sources, a condition known as catabolism. Instead of the body metabolizing external nutritional sources, the diabetic animal burns his own fat and muscle tissue, resulting in a dramatic loss of weight. Animals that have progressed to catabolism can rarely be saved. Treatments include insulin injections and dietary management.

When your cat's electrical impulses in the brain go "haywire," they short-circuit normal brain processes, and seizures may result. *Epilepsy* is a common clinical problem requiring ongoing medical management in small animals.

Feline infectious peritonitis (FIP) turns the cat's immune system against itself, causing neurological signs or

systemic disease that kills the cat. It's caused by a mutation of an otherwise harmless *coronavirus* that for some reason becomes lethal. Initial signs are fever, lethargy, and loss of appetite. These progress to either a buildup of fluid in the abdomen, or a variety of neurological signs. There is an experimental treatment showing promise, but it is not widely available. In most cases, euthanasia is recommended.

Feline lower urinary tract disease (FLUTD), previously called feline urologic syndrome or FUS, is a combination of signs affecting the urinary tract. It's often characterized by the presence of crystals or excess mucus in the urine. However, some cats develop signs of the condition without any crystals present. Cats are prone to urologic disorders because many normally urinate only once a day, and some only once every two or three days. The crystals have more time to develop when sitting in pooled urine for prolong periods of time.

FLUTD affects male, female, neutered, and spayed cats with equal frequency. The kind of crystal depends on the individual cat, the food eaten, and other unknown factors. Middle aged and younger cats tend to develop struvite crystals, while senior citizen cats more frequently develop calcium oxalate crystals. Stress increases the chance for episodes.

Obstruction from crystals and/or mucoid plugs happens oftener in males because of the narrower urethra opening and is an emergency.

Coma and death occur in 72 hours following complete obstruction.

Treatment eliminates the plug, flushes any crystals, and seeks to prevent development of new ones using a therapeutic diet prescribed by the veterinarian.

FLUTD WARNING SIGNS

- 1. A housebroken cat dribbling urine or urinating in unusual locations
- 2. Frequent voiding of small quantities of urine
- 3. Bloody urine
- 4. Urine with a strong ammonia odor
- 5. Squatting or straining at the end of urination
- 6. Listlessness and poor appetite and/or excessive thirst

A classic sign of FLUTD includes urinating in the cool bathtub, the sink, or squatting right in front of you—a feline cry for help!

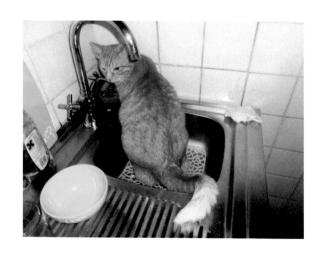

DIAGNOSING THE SICK CAT

Stress, infectious disease, injury, and bodily dysfunctions cause ill health; pain, fever, and behavioral changes are the earliest signs. Call your veterinarian any time you suspect kitty is not well—better a false alarm than a dead cat. The best way to recognize illness is to be familiar with well cat behavior.

A cat's normal temperature ranges from 101 to 102.5 degrees. To take kitty's temperature, get help to gently restrain your cat and ply him with treats to distract him.

If you're alone, gently wrap the cat in a blanket or towel to safely restrain him. Grease a rectal thermometer with mineral oil or Vaseline and insert no further than three quarters of an inch. Leave in place for about one minute before reading.

Take a cat's pulse by placing fingers on the chest just behind and level with the cat's elbow. Normal heart rate is 110 to 140 beats a minute; illness or severe stress may induce rates of 300 or more.

EMERGENCY!

Asphyxiation results from smoke inhalation, choking, strangulation, drowning, or electrocution. Whenever a cat stops breathing, time is of the essence. In life-ordeath instances of drowning or choking, if the obstruction is not easily removable, grasp kitty by the hind legs, and swing; centrifugal force helps dislodge any blockage. Don't be shy and use energy.

If kitty stops breathing, use artificial respiration (rescue breathing). First clear the cat's mouth and throat, then close kitty's mouth. Put your own mouth entirely over top of the cat's nose and blow two quick breaths. Air goes directly through the nose into the lungs when kitty's mouth is properly sealed. Blow just hard enough

to move his sides, and then let the air naturally escape from the lungs before giving the next breath. Give 15 to 20 breaths per minute until he begins breathing again, or you reach the veterinary clinic.

If the heart has stopped, perform cardiopulmonary resuscitation (CPR), alternating chest compressions with artificial respiration. Place the cat on a flat, firm surface. Position your palm over the cat's chest immediately behind the elbow, with your other palm on top; press firmly, then quickly release. Repeat once every second, five times in a row, and alternate with one breath.

Several common house plants are deadly. Philodendron, dumb cane (Dieffenbachia), elephant's ear (Caladium), rhododendron, azalea, mistletoe, and lilies are highly toxic to cats. Please monitor your cat's grazing. She may not eat the plant but playing/scratching the leaves poisons her when she licks clean her claws.

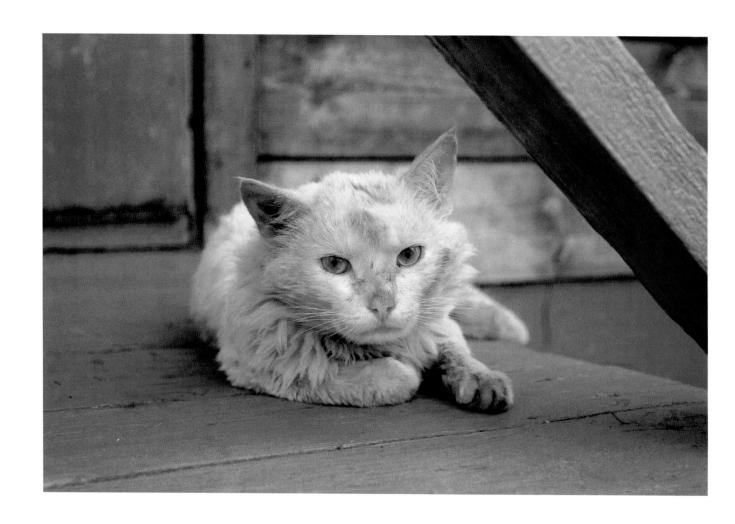

"Nothing's more playful than a young cat, or more grave than an old one."

Thomas Fuller

GERIATRIC MEDICAL CONCERNS

As health care for our feline friends steadily improves, pet cats live longer, healthier lives. Today, many cats live well into their late teens, or even early twenties. A few special cats have lived into their thirties. Because the cat's life expectancy has increased, "old cat" problems are a concern for most cats today.

Arthritis occurs most commonly in the elderly pet, just like in people. For cats, arthritis tends to affect the whole body, so kitty becomes reluctant to move, and sleeps more. He'll often be unable to groom himself thoroughly, jump onto surfaces previously favored, or climb into high-sided litter boxes. Pain worsens in cold, sudden changes in the weather, or heavy exercise. While there's no cure, today there are some safe medications available you can get from your veterinarian that can ease the discomfort.

Dilated cardiomyopathy is a heart disease that may be inherited or develop from a lack of taurine in the diet. Medications can help control the symptoms, but the condition usually means a shorter lifespan for the affected cats.

Nearly fifty percent of major heart problem in cats are due to untreated hyperthyroidism. *Hyperthyroidism* occurs when the thyroid gland secretes excessive thyroid hormones, which results in an increased metabolic rate. Hyperthyroidism occurs in the middle aged to old cat. The cat loses weight but stays hungry, acts irritable, and may develop an oily hair coat and thickened claws. The owner often notices diarrhea,

hyperactivity, and/or increased water intake and urination.

Kidney disease affects nearly half of cats over the age of fifteen and develops slowly over time. Cats show few symptoms until 75 percent of kidney function is gone. The earliest signs are increased thirst and urination, when kidneys can't concentrate urine effectively. Cats seek water in unusual places, like the toilet, and often urinate outside the litter box. Untreated cats refuse to eat, lose weight, suffer weight loss and depression, and develop bad breath that smells like ammonia. Finally, the cat falls into a coma, and dies. Special diets and medication can help control the cat's symptoms and keep renal disease kitties comfortable. This extends their lives for a time.

Lymphosarcoma is the most frequently diagnosed cancer of cats, with cancer of the abdominal organs typical in older animals. Mammary gland carcinoma commonly affects older intact female cats; chances of this developing can be nearly eliminated by spaying before her first heat cycle. Skin tumors and oral tumors are just as dangerous. Any cat tumor is more often cancerous than benign. If you find a lump or bump, DON'T WAIT! See your vet immediately.

Although elderly cats must live with infirmities of age to some extent, preventative maintenance in young to middle-aged cats can make them more comfortable. By preventing problems that occur during the senior years, we often prolong a beloved friend's life.

"With the qualities of cleanliness, discretion, affection, patience, dignity, and courage that cats have, how many of us, I ask you, would be capable of being cats?"

Fernand Mery

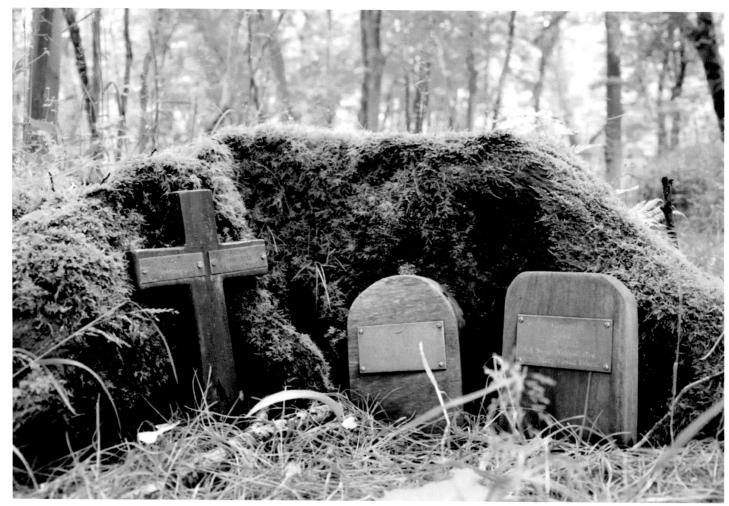

EUTHANASIA

Cats are born; cats live; cats die. Some die tragically in accidents; some slip away easily in quiet old age; others linger with illness, on and on, and in pain. These last deserve our greatest love.

When injury or illness places kitty in prolonged distress with little hope of recovery; when kitty gives up and longs for release; when selfishly prolonging life means but additional pain for the cat—these are situations that may call for euthanasia, a determination that only you, as best friend, can make.

Euthanasia is painless, consisting of a single needle prick followed by one last quiet breath. Most veterinarians agree to your being with the cat, to offer comfort as he passes on. You loved your cat best—only you will know when the time is right to end the suffering. Have faith in your decision, for it is the finest final gift you can give.

Then after a time, celebrate your cat's life—not by replacing him, but by remembering, with another of his kind. Other cats need you, and such unselfish love should not be wasted.

OLD CATS

A tabby named Ma from Devon, England, was put to sleep at the age of thirty-four in 1957. Another Devon tabby named Puss celebrated his thirty-sixth birthday on November 28, 1939 and died the next day. What is it with Devon and cat longevity?

More recently, Texas kitties equaled and beat the record. Grandpa Rexs Allen, a Sphynx/Devon Rex cat, lived thirty-four years and two months, and died in 1998. Cream Puff, a tabby boy owned by the same Texas family, lived to be thirty-eight years and three days old before his death in 2005.

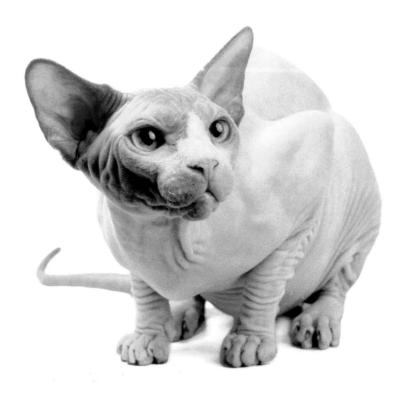

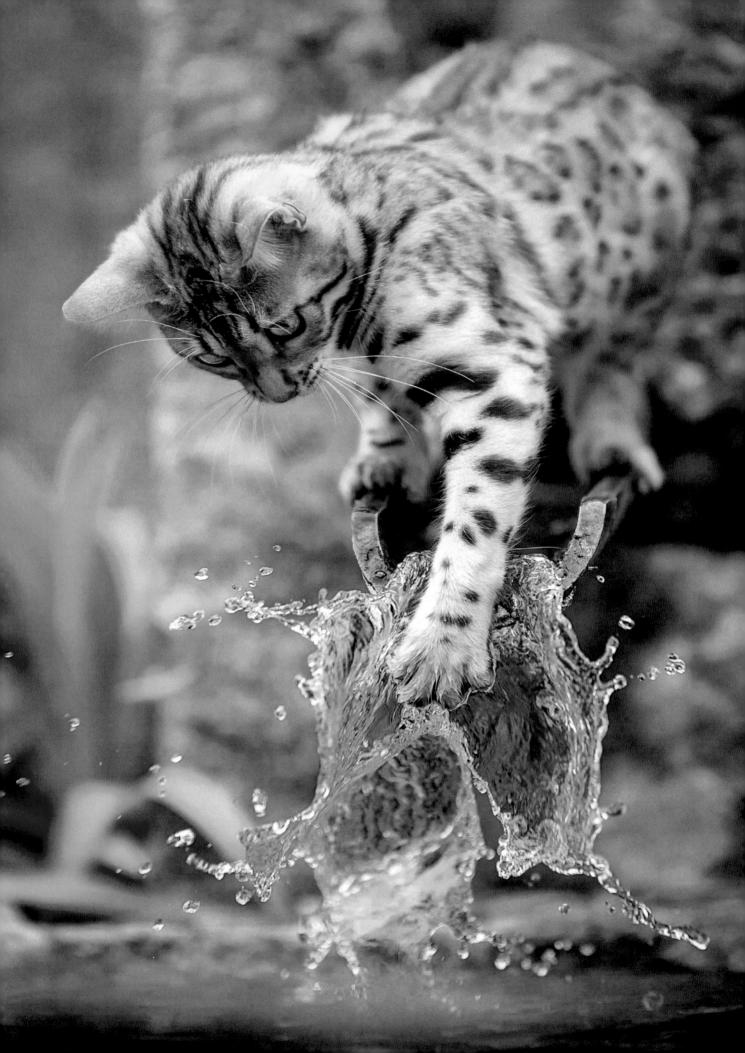

Four: GALLERY OF

BREEDS

CHOOSING YOUR CAT

ecisions, decisions: kitten or adult? Longhaired or shorthaired? Purebred or alley? Kittens are awfully cute, and pedigree cats offer exotic looks and an anticipated personality. But adults are more settled, and mutt cats are endearing, healthy, more needy—and often free when they show up on the back porch.

Whatever you decide, a healthy cat is best. Fur should be glossy, eyes should be bright with interest, and eyes, ears, and nose should be free of gummy deposits or discharge. Check kitty's bottom for signs of diarrhea or tapeworm segments. The belly should feel rubbery, not hard or flabby.

Temperament is just as important as health. The cat should not be timid, but willing to make friends; a kitten ought to be eager to play, and ready to forgive loud, sudden noises and be coaxed back to you. A cat that fails these tests may remain aloof or skittish around people her whole life.

Always support the body; don't let kitty dangle from the armpits. Lift a cat with one hand beneath the chest just

behind the front legs, with the other cupping the posterior. Hold up the tail to determine the sex of a kitten. A girl kitten's anus and vulva look like a semicolon; boy cat's bottom looks more like an exclamation point.

When introducing a second cat, include new litter pans, bowls, and toys for New Cat to reduce Old Cat's irritation. Most kitties act cranky until reassured that their place in your affections hasn't been usurped. Have someone else deliver New Cat, so Old Cat won't blame you—and let the cats meet initially only through a solid closed door, behind which the New Cat resides for the first week or so. Once any hisses fade and only interest and paw-pats under the barrier occur, you can open the door for the cats to get acquainted. Let them interact at their own speed—ignoring each other is fine. Until they become friends, separate the cats when you cannot supervise. Some friendships are immediate, but others take time, so be patient.

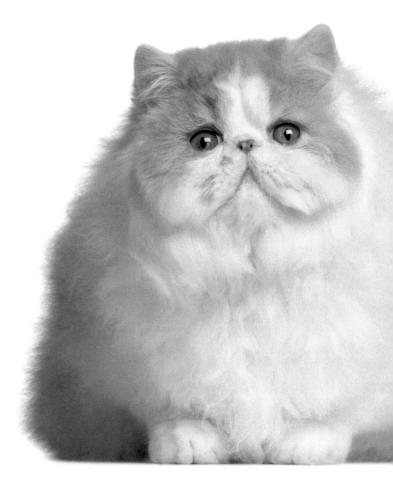

CAT TYPES

refined the type. *Man-made breeds* like the Bombay are hybrids created by combining existing breeds to form new ones. *Spontaneous mutations* are the third breed type and are inexplicable deviations from nature; examples are the taillessness of the Manx, the folded ears of the Scottish Fold, and the baldness of the Sphynx.

Cobby (Persian) type is solidly built with short, thick legs, broad shoulders and rump, and short, rounded head with flat face, and almost round eyes.

Domestic (American Shorthair) has a muscular chunky body, medium-length legs, average shoulders and rump, short neck, medium-length rounded head, and almond or round eyes.

Foreign (Siamese) is a lithe, lightly build cat with long slim legs, narrow shoulders and rump, and long, narrow wedge-shaped head with widely spread and sometimes slanted

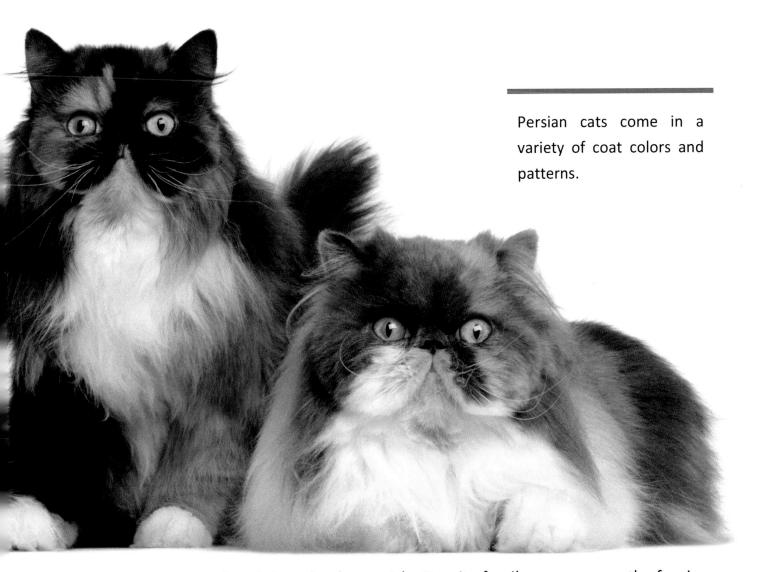

eyes. Ears are more pointed than the domestic's. Despite fragile appearance, the foreign is as sturdy as the domestic.

Cat breeds as well as random bred "mutt" cats come in an amazing variety of shapes, sizes, colors, and patterns. Registering associations for pedigreed cats demand standards for each breed; however, standards vary from one association to another, and breeds accepted in one may not be recognized by others.

"Tabby" is derived from this fur pattern's resemblance to the markings on black-and-white watered silks, which originated from El Tabbiana, near Bagdad.

COAT TYPES

ats have four types of coat; down is the soft undercoat that keeps kitty warm; awn hairs are the middle hairs that insulate and protect the skin; guard hairs are the longest and thickest and provide a protective outer coat; vibrissae are the whiskers.

Shorthair cats include the peach fuzz coat of the Sphynx, the fine single coat of the

Bombay, and the plush double coat of the Chartreux. Most shorthair coats are straight, but the rex coat curls, waves, or ripples as in the American Wirehair, Cornish Rex, Devon Rex and similar breeds. Longhair coats vary from two to six inches long depending on the breed.

Patterns include agouti (bands of ticking on each individual hair); tabby (spotted, classic/marbled, and mackerel/striped); bicolor (two solid colors); tortoiseshell (mixture of red and black); tricolor; tipped (light hair with dark tip, or dark with light tip); and pointed (light body with darker "points"—face, lower legs, tail).

Colors include white, black, blue (shades of gray), chocolate, cinnamon, lilac/lavender (very light gray), fawn, red, cream, ruddy, sorrel, champagne, platinum, mink, caramel, beige, apricot, indigo, and silver (tipped/smoked cats).

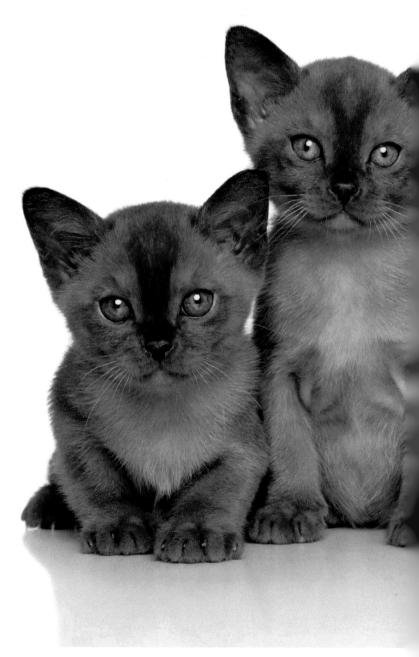

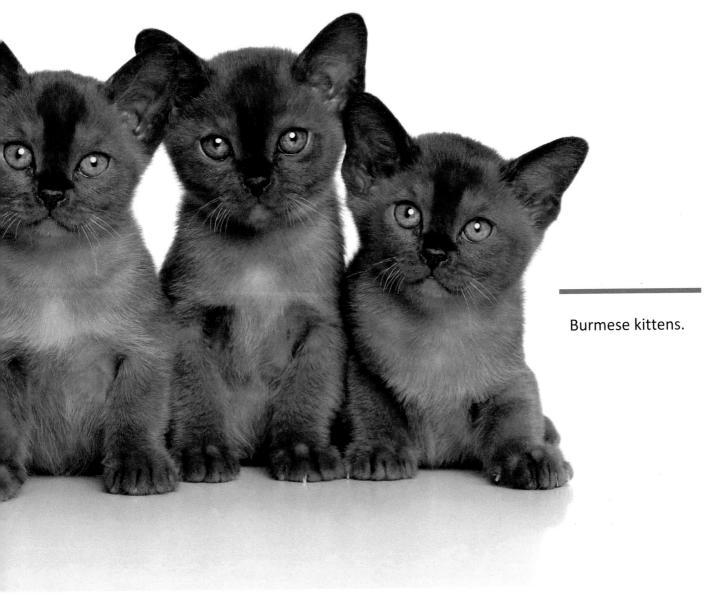

GALLERY OF BREEDS - 105

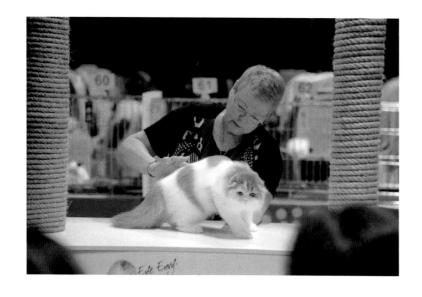

Cat show judge Diana Rothermel examines a Persian at a March 2018 cat show in Bangkok, Thailand.

CAT ASSOCIATIONS

America Association of Cat Enthusiasts (AACE)
http://www.aaceinc.org

American Cat Association (ACA)
Ms. Irene Gizzi
11482 Vanport Ave
Lake View Terr. CA 91342
818-896-6165
http://www.americancatassociation.com

American Cat Fanciers' Association (ACFA) P.O. Box 1949, Nixa, MO 65714-1949 417-725-1530 http://www.acfacat.com

Canadian Cat Association (CCA) 5045 Orbitor Drive Building 12, Suite 102 Mississauga, ON L4W 4Y4 905-232-3481 http://www.cca-afc.com Cat Fanciers' Association (CFA) 260 East Main Street Alliance, OH 44601 330-680-4070 http://cfa.org/

Cat Fanciers' Federation (CFF) CFFinc@live.com 937-787-9009 www.cffinc.org

Fédération Internationale Féline (FIFe) http://fifeweb.org/wp/lnk/lnk_org.php

The International Cat Association (TICA) PO Box 2684 Harlingen, Texas 78551 956-428-8046 www.tica.org

World Cat Federation (WCF) http://www.wcf-online.de/WCF-EN/index.html

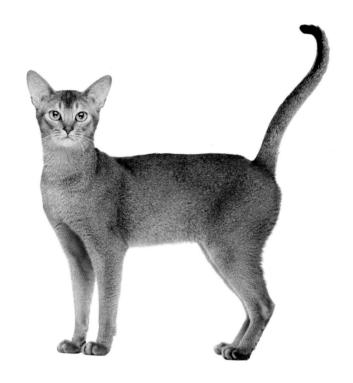

AMERICAN BOBTAIL

This cat developed from selecting feral cats with naturally occurring bobtails. Breeders have described them as intelligent, watchful cats with a sense of mischievousness. While some speculate that foundation feral cats arose from bobcats breeding with domestic kitties, today this isn't considered likely.

Males often reach twenty pounds, and come in all colors and patterns, with preference for those similar to wild cats. They come in a dense shorthair coat, or medium longhair coat.

As the name implies, Bobtails have abbreviated flexible tails in various lengths. Tails may be straight, curved or kinked, sometimes with bumps along its length. Usually a quiet cat, the Bobtail trills, chirps, and clicks when delighted.

ABYSSINIAN

The Abyssinian (above) looks like a miniature cougar and is a medium size breed first developed in England about 1868. Abys have distinctive agouti coloring that looks like wild rabbit fur; in fact, in the past they were called Bunny Cats, and thought to result from a cross between a cat and wild rabbit. Each hair is ticked with two to three bands of color, giving the short, silky coat a wild look. Abys are accepted in different colors by various breed associations: ruddy, red (sorrel), blue, fawn, lilac, cream. The green or gold-eyed Abyssinian is a fine-boned yet muscular, regal cat that seem to be always on tiptoe.

Curiosity and avid interest describe the typical Aby. This cat won't sit still long enough to make a good lap cat. Instead, his intelligence and athletic ability make him a mischievous cat who becomes easily bored without lots of attention. Abys love to climb, jump and race, and may prefer perching on the tops of doors and scaling drapes to napping. They tolerate other cats but prefer attention all to themselves. Abys are wonderfully entertaining, extremely affectionate in-your-face cats.

AMERICAN CURL

The American Curl (above) has distinctive ears that curl backward from the face. She is a semi-foreign type, but not cobby, and comes in either short or long fur, and in every color in the rainbow. The breed was founded by Shulamith, a stray black longhair kitten with curled ears discovered in 1981. All true Curls today are related to her. Because these cats are descended from an enormous gene pool of domestic cats, they are generally very hardy, healthy cats remarkably free of genetic defects. Betty Bond, a breeder of Curls, calls them a curious cat. "Curls have more stamina than Scottish Folds and are very playful, without being wired."

Curls are whimsical, attractive kitties. Unlike the soft ears of most cats, the ear cartilage in Curls feels firm like human ears. Kittens are born with straight ears that curl between two to ten days of age, then furl and unfurl until they reach their permanent shape usually by six months. Some Curls end up with straight ears. Any coat color, pattern, or length is acceptable in this medium size cat. Curls tend to be people cats who want to be in on everything. They retain a kittenish exuberance for life, and never seem to outgrow their delight in play. Curls enjoy being with other cats, as well as children.

AMERICAN SHORTHAIR

The American Shorthair (above) is the archetypical farm cat. This is a medium to large, strongly built cat made for work. In the early 1900s, those interested in preserving these qualities began selectively breeding the finest examples, which they called Domestic Shorthairs.

In 1966, the breed became known as the American Shorthair, and is distinct from the random bred cat down the street that by chance may look similar.

American Shorthair cats come in a variety of coat colors and patterns. The fur is always short, thick, and hard in texture. They are loving cats, remarkably hardy and resistant to disease. These athletic felines have retained their hunting skills and enjoy being with other cats.

AMERICAN WIREHAIR

In 1966, a spontaneous mutation produced a kitten with a distinctive crimped coat of medium length wiry fur. Unlike his littermates or either parent, red and white Adam the barn kitten had a soft "brillo-pad" coat and curly whiskers. He became the founding father of the American Wirehair breed, which is still considered a relatively rare cat. The coat feels like a soft, woolly lamb. This is an endearing, versatile cat.

Wires demand little grooming, are quiet cats, and tend to be the dominant force in any group of cats. These medium to large cats come in a variety of coat colors and patterns. They aren't terribly active and may prefer to watch from a distance rather than be in the middle of things.

"A cat has absolute emotional honesty; human beings for one reason or another, may hide their feelings, but a cat does not."

Earnest Hemingway

BALINESE

The Balinese (above) is a lithe, long-bodied blue-eyed cat with pointed coloring and a silky long coat. Her most distinctive feature is a luxurious tail plume. American cat enthusiasts began promoting the Balinese as a new breed in the late 1940s when Siamese cats gave birth to longhaired kittens. The Balinese cat was named after the graceful dancers of Bali, and their Siamese heritage. Coat length is the only difference between the Siamese and the Balinese.

Unlike some other longhair cats, the Balinese does not have a heavy double coat; the silky single coat lies close to the body. Like the Siamese, the Balinese is born white, and develops points as she matures. She's a talkative cat that bonds closely with her people. These cats can be very energetic and demand much attention. Balinese are also said to be quite protective of their loved ones.

BENGAL

The Bengal (right) is a hybrid cat produced by crossbreeding the Asian leopard cat with American

Shorthairs. For years breeders wanted to create a domestic feline with the look of an exotic wild cat and the temperament of a lap cat. Success came in the 1980s by breeding spotted tabby American Shorthairs with leopard cats. The Bengal has only been recognized as a true breed by some registries since 1991.

Roger Davis breeds these athletic, exotic-looking cats. "Bengals figure things out," he says. "Nothing's sacred in the house, but they do it in such a way you can't get upset with them." A good Bengal slinks when he walks, with low tail carriage like wild cats. Although Bengals have a wilder-sounding scream than most domestic kitties, they tend to be enthusiastic purrers.

This leopard look-alike comes in a variety of colors in either spots or a "marbling" coat pattern. To ensure Bengals remain a true domestic breed, cats must be several generations removed from their wild cousins. At least four generations of Bengal to Bengal breeding is required if that cat is to be shown. Owners describe Bengals as doglike, in that they enjoy playing fetch and walking on a leash and get along well with other pets and people. They demand to be the center of attention.

A cat is a lion in a jungle of small bushes.

Indian proverb

LEGEND: When the priest Mun-Ha died, his soul went into his cat Sinh; abruptly, the cat's golden eyes turned blue, hair along his spine became gold, and brown feet blanched white where they touched the holy man. Not only Sinh, but all the Temple cats changed, miraculously creating the Sacred Cat of Burma.

BIRMAN

The Birman (above) is an ancient breed native to Burma raised as temple cats there for hundreds of years. Imported to France in 1919, the breed was nearly lost during World War II; only one pair of Birman cats remained and founded the breed we know today. Birmans were recognized in the United States in 1967.

The Birman is a large, stocky, long bodied blue-eyed cat with easy care semi-long fur that rarely mats. Birmans are born solid white, and adult color develops over time. Predominately white or cream fur on the body is misted with gold and accented by dark masks and legs usually in seal point (dark brown) or blue point (slate gray).

The Birman's distinctive white feet look dipped in sugar. Birmans are family cats that enjoy contact with

children or other pets, and relish games of fetch. They are talkative yet soft spoken cats with a low-slung tiger-like gait, and always enjoy petting. This kitty's personality is somewhere between the placid Persian and extrovert Siamese—an affectionate, inquisitive cat.

BOMBAY

The Bombay (below) is a black patent leather cat. He's a medium size cat with extremely short, close-fitting jet-black fur, and golden eyes. These "parlor panthers" were named for the city of Bombay because of their resemblance to the Indian black leopard.

Bombays resulted from breeding a black American Shorthair to a sable Burmese. In body type, the rounded head and muscular body make the Bombay look similar to the Burmese, but the coat color with its satin-like texture make this cat different than any other.

The easy-care coat and gregarious personality make Bombays wonderful pets. Smart and easily trained, these cats fetch naturally. They like lap sitting and enjoy other cats and children.

BRITISH SHORTHAIR

The British Shorthair (above) is to Great Britain what the American Shorthair is to the United States. These cats were found in the cities and farms all over the British Isles and were prized as mousers. A British Shorthair cat was awarded the Best In Show prize at the very first organized cat show that took place in England in 1871.

British look similar to the American Shorthair but have a slightly rounder face and are known for their short, plush weather-resistant coats. They come in a variety of colors, though for a time the blue (dark gray) variety was so popular it was referred to as a separate breed and called the British Blue.

These smiling cats are calm, congenial pets that are independent, yet delight in children. They mature slowly, and fanciers consider them at their show peak at about five years of age.

"A cat is there when you call her—if she doesn't have something better to do."

Bill Adler

BURMESE

The hybrid Burmese cat's ancestors probably originated in Burma. The founder of today's breed, a dark brown cat brought to San Francisco from Rangoon in 1930, was bred to a Siamese. First registered in 1936, the Burmese of today is a medium sized solid boned cat surprisingly heavy for his size. The most popular color is sable brown, but recently other colors have become popular. Gold or yellow eyes are preferred. The short coat takes minimal care.

The Burm (above) is an animated cat that likes to talk and wants to be in the middle of things. They leap great distances effortlessly, and are equally at home in your lap, or lounging on the tops of doors. They prefer being an only cat (more attention for them that way!) but do get along with other cats and pets.

BURMILLA

The Burmilla (above) developed from an accidental breeding of a Burmese with a chinchilla Persian, resulting in a cat type halfway between a British Shorthair and a Burmese. The Burmilla has big green eyes, and a short, dense, silver-tipped coat. He is a playful, gentle cat, and comes in colors of silver or gold ground, with a tipped mantel darker along the spine in black, sepia, blue, chocolate, lilac, caramel, beige, red, cream, or apricot. The tail has distinct rings and is tipped in the color of the shading.

CALIFORNIA SPANGLE

Paul Casey developed a spotted, wild-looking cat by combining, in series, an old-style (apple head) Siamese with a spotted silver Turkish Angora. The offspring (a silver male with blocky spots), was bred to British Shorthair, American Shorthair, spotted brown tabby Manx and Abyssinian. The final generation added street cats from Egypt and Malay to get the final look.

This shorthaired cat comes in silver, bronze, black, white, charcoal, gold, red, blue, and brown, and has darker spots dotting the body. Casey introduced the breed for sale in Neiman Marcus catalogues for \$1400, and the cat remains quite rare.

CHARTREUX

The Chartreux (below) is a shorthaired thick-coated cat sporting dark blue-gray water repellent fur. He has been described by some as a "potato on toothpicks" because of his solid body balanced on rather short, finely-boned legs. This breed has a sturdy, broad-shouldered bearlike look. The cat, known for his sweetly smiling face, originated in France. Some think the Chartreux to be a very old natural breed developed in France during the Middle Ages by La Grande Chartreus monastery

monks. Others believe it to be a hybrid of French street cats and the British Blue Shorthair.

Chartreux enjoy playing fetch and often learn to come when their name is called. A rather quiet cat that prefers chirps to meows, Chartreux cats thrive on attention and are loyal family members. He often prefers the company of people and dogs to that of other cats.

COLORPOINT SHORTHAIR

The Colorpoint Shorthair is essentially a Siamese cat with nontraditional point colors. These cats developed from Siamese bred to British or American Shorthairs or Abyssinians. Today some cat associations recognize Colorpoints simply as Siamese, while other associations register this cat as a separate breed.

Like Siamese, the Colorpoint is a shorthair foreign-type cat with blue eyes, and body color of white or off-white. The points come in solid colors of red or cream, lynx point in tabby patterns and colors, and tortie points of tortoiseshell colors. Colorpoints are loving cats that bond closely with all family members.

"I've met many thinkers and many cats, but the wisdom of cats is infinitely superior."

Hippolyte Taine

CORNISH REX

The Cornish Rex cat's unique look (above) includes a Greyhound-like body with short curly fur missing a coarse topcoat. The Cornish Rex first appeared in 1950 as a spontaneous mutation in Cornwall, England. The breed developed by crossing these cats with Siamese, which defined the Cornish Rex's rangy, distinctive appearance.

These cats are very athletic, and great climbers. Their wiry coat sheds less than some other breeds, which makes them easy care cats. They get along well with other cats and people, including children, but their dainty structure precludes any roughhousing.

DEVON REX

The Devon Rex appeared in 1960 when a curly coated kitten was born to a feral cat living in Devonshire, England. The pixie-like appearance of the Devon includes huge ears, an elfin face, large round eyes, and a hard, muscular body covered with soft wavy fur that resembles lamb's wool.

The Devon has a somewhat thinner coat than the curly coated Cornish Rex, and while the Cornish has a Roman nose, the Devon has a definite stop or indentation to the nose. The Devon is an extremely active cat, and is people oriented, and prefers lap-sitting to window-gazing.

"The smallest feline is a masterpiece."

EGYPTIAN MAU

This spotted, somewhat shorthaired cat (below) is thought to resemble one of the oldest breeds, dating back to 1400 B.C. Ancient Egyptians revered the cat. Mau is the Egyptian word for both "cat" and "light." Spotted felines similar to today's Maus are depicted on the walls of Egyptian tombs.

These green-eyed cats are the only natural breed of domestic spotted cat. Their body is randomly spotted, with banding on the legs and tail. Coat colors are darker spots on lighter solid background, in either coppery brown, silver, or silver background with black spots.

The Mau is an athletic cat that mimics the cheetah's slinking gait. This breed needs much handling as a kitten to be properly socialized, because they tend to be reserved, and fiercely independent. Maus prefer to be the only cat and are affectionate toward family members. She makes an unusual, sweet, chirp-like sound.

EXOTIC

This plush coated moderately shorthaired cat (above) is a hybrid of the Persian and American Shorthair cat breeds. The Exotic is a Persian in body type and temperament, but with a teddy bear coat.

Like Persians, this breed comes in a variety of coat colors and patterns. Quiet, undemanding, and exceedingly affectionate cats, Exotic cats are loyal companions who enjoy lap sitting but aren't a bother about it. They like interactive games as much as the next cat, but these laid-back kitties prefer quiet time with owners to athletic endeavors.

The cat has nine lives: Three for playing, three for straying, three for staying.

English proverb

HAVANA BROWN

This chocolate-colored shorthaired breed originated in England and is a medium size cat with brilliant green eyes. Some say the name comes from the cat's color similarity to a Havana cigar, others to the Havana rabbit of the same color.

The Havana (below) has a uniquely shaped muzzle unlike that of any other cat breed. Described alternately as a corncob or light bulb stuck on the face, the Havana has a decided stop or indentation where the nose meets the eyes, similar to a dog's muzzle.

Sheila Ullmann breeds Havanas, and says they're extremely trainable, and can be halter and leash trained. "Havanas are very devoted to any human; even older cats will readily attach to new owners," she says. "They are very oral and enjoy grooming each other. They think it's wonderful to clean their human, too, and will groom your hair at night when you're trying to sleep."

Havana Brown cats tend to be quiet, affectionate cats that enjoy the company of people and other pets. They like to be in the middle of things. Breeders describe their coats as easy care.

HIMALAYAN

This cat (above) is recognized as a separate breed in some registries, and as a color pattern of the Persian breed in others. It really makes no difference to the cat, whose striking features make her a standout whatever her designation.

The Himalayan was created by breeding Persians to Siamese cats to achieve Persian body type and coat with Siamese pointed coloring and eyes. Himalayans have the sweet laid-back temperament of the Persian and get along well with other cats.

JAPANESE BOBTAIL

This natural breed (above) has been a native of Japan since the seventh century but was first introduced to the United States in the late 1960s. The Japanese Bobtail's corkscrew tail fans into an attractive poof on his rump. A recessive gene causes the tailbone to twist and curl and the vertebrae to fuse. This distinctive tail is found nowhere else in the cat world.

The Japanese Bobtail is in no way related to the tailless Manx. High cheeks and a long parallel nose give unique character to the face. The Bobtail is a shorthaired, slender but sturdy cat and comes in all coat colors except pointed or the agouti coat of the Abyssinian. Preferred colors are combinations of white, black and red.

Breeders describe these cats as active, soft-spoken yet talkative pets who enjoy games of fetch and are particularly good with children. They also accept other pets and dogs. They are active but not hyper, eat ravenously, have sunny dispositions, and are extremely vocal. The Japanese Bobtail is a curious cat that likes to explore.

JAVANESE

The Javanese breed is virtually identical to the Colorpoint Shorthair cat, except for the coat length.

The Javanese fur is longer and softer and is described as a silk chiffon coat.

Liz Layton, a breeder of these exceptional kitties, say's they're one of the best children's cats she's ever seen. "Javanese are very trainable cats. My cat Akai will come, sit, and stay on request." Liz's other cats often learn just by watching older kitties. "Javanese are also great shoulder cats," says Liz. "If you have more than one, they'll compete for the shoulders!"

This dainty-appearing cat is extremely vocal, a characteristic inherited from Siamese ancestry. The baby-fine medium-length fur requires minimal grooming, and rarely mats. Javanese are people cats that want to be in the middle of everything.

KORAT

This breed is a native of Thailand and boasts a distinctive silver blue coat and luminous green eyes that appear too large for his somewhat heart-shaped face. It may take up to four years for the eyes to develop their true adult color. The short fur lies closed to the body, and each hair is blue tipped with silver. Korats are medium sized muscular cats. Considered a bringer of luck, the Korat is one of the four major blue breeds and is somewhat rare even in Thailand where he is known as the Si-Sawat.

The Korat is a quiet, gentle cat that dislikes loud or sudden noises. They are devoted to their special people, enjoy lap sitting, but indulge in active play as well. They will accept other pets but tend to want their human's exclusive attention.

LaPERM

In 1982 on a farm in Oregon, a kitten born hairless with tabby cat markings became the basis for the LaPerm breed. By eight weeks old, the kitten had grown a curly

fur coat. Today, the breed sports coats with curls ranging from tight ringlets to soft curls or even long corkscrew curls. The tightest curls appear on the throat, tummy, and base of the ears. Longer fur on the tail and back may part down the middle.

LaPerm cats come in almost every color and pattern. Kittens often become bald shortly after birth, with the curly coat reappearing in the first sixteen weeks.

As with other Rex (curly) coated cats, LaPerms love people. They're curious and enjoy exploring, but also are happy to nap away the day on a favorite human's lap.

LYKOI

Also known as the werewolf cat, the name Lykoi means "wolf cat" in Greek. The new breed (above) emerged as a mutation discovered in feral cat litters around 2010. The unusual looks, at first thought due to ill health,

instead results from a recessive gene. Interested breeders outcrossed the cats with domestic black felines to keep the werewolf look while preserving the health of the partially hairless breed. Lykoi only recently appeared in experimental classes in cat shows.

Lykoi cats grow only the harsh outercoat, often black mixed with pigmentless hairs that makes cats look dusted with silver—a roan pattern more common in dogs. The eyes, chin, nose, muzzle and behind the ears rarely has any fur, and exposed skin feels like leather. Amount of fur varies from cat to cat. Lykoi cats have lean, strong, moderate-size bodies, and wide-set pointed ears that makes them look wolfish. They are energetic cats that retain high prey drive, perhaps due to their feral ancestry. Lykoi cats may target smaller pets in stalking games.

MAINE COON

This breed (below) appeared naturally, and is a native American longhaired cat first recognized in Maine. The Maine Coon is one of the largest breeds, with adult males reaching 20 pounds in weight. Tony Kalish, a breeder, says, "The average weight is eighteen to twenty pounds for males, and ten to fifteen pounds for females—not the thirty-plus pounds often reported. Coons feel heavier because they have such muscular bodies."

Despite folklore to the contrary, the cat has no common ancestry with racoons. More likely, the name arose because early cats sported tabby rings on fluffy tails that looked like racoon tails. They are substantial cats with stout legs, a round head, and large round eyes. The coat's silky guard hair has no undercoat and needs regular grooming. These kitties are mature by age four to five years.

The Maine Coon's shaggy coat comes in a variety of colors and patterns. Coon Cats are a muscular breed, often nicknamed Gentle Giants for their calm, kind natures. These cats are loyal, quiet cats who get along well with other pets and children. Their coat takes less care than other longhaired breeds and will remain matfree without a lot of grooming. These active cats need space to exercise. They enjoy playing with water and will get into the tub with you. "They're extremely gregarious," says Tony, "and have no sense of propriety. They never grow up; no matter their age, they have a childlike quality."

MANX

The Manx cat is the definitive tailless cat. This is an old breed that has been popular for over 100 years. Manx originated on the Isle of Man in the Irish Sea off the coast of England about the sixteenth century. Legend holds that tailless cats swam ashore after a shipwreck and colonized the island, but nobody knows for sure how the cats came to arrive.

LEGEND: The Manx lost his tail when Noah closed the Ark door too soon and cut it off.

Manx look like a British Shorthair, but longer rear legs give him a raised rear end, like a race car. The mutant gene responsible for taillessness results in only a small hollow where a tail would be.

Manx can have varying degrees of taillessness: rumpies are completely tailless; risers have only a small bump where the tail should be; stumpies sport an abbreviated tail, either straight, kinked or curled; and longies are Manx cats with full length tails. Unfortunately, the gene that produces taillessness can also cause a variety of crippling spinal problems.

The Manx cat's short thick fur comes in a variety of colors and patterns, except chocolate, lavender, or point pattern. He is medium sized cat with a round face, and a short back that arches to a rounded rump and long

back legs. Manx breeder Elaine Dunham characterizes this cat as full of fun. "They're very playful and loving, and can jump straight up off the ground, as if on springs." Manx are wonderful companions and are described by some as clown-like in behavior. They are people cats that love to cuddle on laps.

Pronounced "kim-rick," the Cymric developed from mutant kittens from Manx litters during the 1960s and was recognized for show in the 1970s. The Cymric is a Manx with long, silky fur.

NORWEGIAN FOREST CAT

"Skogkatt" means "forest cat" and is the Norse name for this large natural longhaired beauty. The Norwegian Forest Cat (above) is said to have accompanied the Vikings on their many voyages. To the uninitiated, he looks very similar to the Maine Coon, and in fact some people speculate he may be a forebear of the younger American breed. Those who know say the Forest Cat

has a boxier build, a more triangular face, and lowersetting ears than the Maine Coon. Norse legend describes just such a mysterious, enchanted animal.

The Norwegian Forest Cat is a large strongly built breed known for his impressive weather-resistant double coat. He comes in nearly all colors and coat patterns except pointed and has green to gold eyes. The breed does not fully mature until five years of age.

Lynne Boroff breeds these magnificent cats and describes them as very outgoing, almost puppylike in behavior. "They'll come to the door to greet you when you come home. They're very athletic and are great climbers and can jump straight up like a yo-yo."

The extremely long outer guard hairs are silky to the touch, and the thick undercoat is cottony soft and thick. This undercoat is shed each spring. The long fur requires little maintenance beyond occasional combing, especially during shedding. The "Wegie" is a gentle people cat that enjoys being a part of the family. They demand attention but are quiet and don't meow all day long.

OCICAT

The Ocicat (below) is a large athletic shorthaired cat covered with distinctive dark spots on a light background that make him look like the wild ocelot. The first Ocicat appeared in 1964 as the result of an experimental breeding arranged to produce Aby-point Siamese. Instead, a cream-colored cat with golden spots appeared, and the Ocicat was born. Today Ocicats are seen in a rainbow of colors. Their eyes can be any color but blue.

This man-made breed weds the allure of the exotic wild look with the predictable, lovable disposition of the pet cat. Ocicats are said to have a dog-like devotion to their special people and make great family pets. They are quite easy to train and are not bashful with strangers. They don't like being left alone, though, and prefer to be in the middle of things. Ocicats get along well with other pets.

ORIENTAL LONGHAIR

The Oriental Longhair is a hybrid cat with ancestry that includes the Siamese, Colorpoint Shorthair, Oriental Shorthair, Balinese, and Javanese. Her body type and shape are very similar to all these breeds.

The coat is long, fine and very silky to the touch, but lies close to the body to give the cat a well-groomed, svelte appearance. The furred tail looks like a plume. Coat colors and patterns are virtually anything you can imagine. This relatively new breed is basically a longhaired Siamese cat that comes in all the colors of the rainbow.

ORIENTAL SHORTHAIR

This cat is essentially a Siamese cat wedded to the rainbow of coat colors and patterns found in the

American Shorthair. Breeders have described the Oriental Shorthair as a Siamese in designer jeans.

Like the Siamese, this breed is a lithe oriental type cat of medium size with a short fine coat. Though delicate boned and almost dainty in appearance, this is a strong muscular cat bursting with energy. Orientals (above) become very attached to their people and may prefer to be one-person pets.

PERSIAN

The Persian breed is arguably the most popular and recognizable breed of cat. These cats are said to be named for their country of origin, but their true beginnings may never be known. They were the first longhaired cats to reach Europe, sometime in the late 1500s. Persian cats have full long coats, and their short square bodies are the archetypical "cobby" type. They have distinctive wide flat faces with large round eyes.

Persians come in a variety of coat colors and patterns. The luxurious coat of the Persian cat has been developed to the point that only a protected indoor lifestyle is appropriate. Persians require a great deal of maintenance on an owner's part, including daily grooming and regular bathing.

Persians are quiet serene cats that enjoy playing but are not boisterous. They prefer lap sitting and posing for admiration, to climbing or leaping. These gentle gorgeous cats make wonderful pets.

RAGDOLL

The Ragdoll breed (below) arose in the 1960s in California from Ann Baker's white cat (Josephine) thought to be a mix of a seal point Birman, and white Persian and possibly others. The Ragdoll came by the name for her tendency to go limp when held. The Ragdoll is the largest cat breed, with male cats tipping the scales by twenty pounds or more. These longhaired blue-eyed cats are also known for their extremely sweet, gentle nature. Coat patterns include bicolor, colorpoint or mitted (white feet). The related Ragamuffin looks similar but comes in many other colors and patterns and doesn't tend to go limp.

RUSSIAN BLUE

His refined graceful boning, emerald eyes, and sliver-tipped short blue fur makes the Russian Blue a standout among cats. At one time known as the Archangel Cat for his origination near the port of the same name on the White Sea, the breed arose in the Baltic area. This foreign-type cat has short double-coated blue fur tipped with silver so plush it can be stroked both ways without exposing the blue skin. The eyes must be vivid green.

Russian Blues (above) tend to be cautious with strangers and slow to become acquainted. They are extremely agile cats who like to cram themselves into nooks and crannies, and never seem to outgrow their enjoyment of playing games. Because of their reserved personality, Russians are more suited to being only cats and do not do well in households with large numbers of other pets.

SCOTTISH FOLD

The Scottish Fold (right) is named both for her country of origin and for ears that fold forward over her head. The distinctive ears give the cat a teddy bear or owl-like appearance. The breed developed from a folded ear barn cat found in 1961 on a farm in Scotland.

The Fold is a medium cat with a rounded body and short dense fur. Kittens are born with straight ears that begin to fold at about three to four months of age. Some Folds have straight ears but may nevertheless produce fold-eared kittens.

Breeding a straight-eared fold to a fold-eared cat results in about 50 percent of the kittens in the litter having folded ears. Breeding a fold to a fold increases the numbers of fold-eared kittens, but also increases the risk of crippling bone abnormalities. Thick or poor mobility in the legs or tail indicates problems.

Scottish Folds are sweet tempered cats with quiet voices and ways. Breeder Betty Bond describes her Scottish Folds' personalities as being almost Persian-like, but not quite as laid back. "They're a little more playful, but totally relaxed, and adjust their personality to whatever they're around." They tend to adjust well to multi-cat or pet households and get along well with children. They come in nearly every coat color. Some cats need their ears cleaned more often due to waxy buildup.

The Scottish Fold Longhair is identical in every way to the shorthaired Scottish Fold, except for semi-long fluffy coat. Some cat associations call the breed the Longhair Fold or the Highland Fold. They require almost daily grooming to keep the coat in shape.

SELKIRK REX

Another natural mutation created the Selkirk Rex that first appeared in a Montana shelter cat. Cat breeder Jeri Newman adopted the feline, named her Miss DePesto (after the secretary in the TV show "Moonlighting")

and bred her with a Persian. Three of the six kittens also sported the curly fur and whiskers of their mother.

Selkirk Rex (below) are similar in size and shape to the British Shorthair with a round head and loose curls. Coats come in both long and shorthair, with more prominent curls in longhair varieties. They are considered patient, loving, and tolerant of other pets.

SIAMESE

The Siamese (below) is one of the oldest, best known and most popular cat breeds in the world. This is the

native cat of what today is known as Thailand. The Siamese was treasured by royalty and protected within temple walls for at least two centuries.

The Siamese is a foreign type lithe shorthair cat with a triangular face, muscular tubular body and intensely blue eyes. He is best known for his pointed pattern, which consists of a lighter colored body with solid contrasting colored legs, ears, tail and mask.

Siamese cats have a distinctive voice and are known to be talkative cats. They love to be part of a family. Siamese are considered quite dog-like because of their natural inclination to play fetch, follow their owners, and bond closely with people.

SIBERIAN CAT

A native cat of Russia, the Siberian (above) is another forest cat similar in type to the Norwegian Forest and Maine Coon cat breeds. He came to the United States in 1990.

This large, rugged, longhaired cat has a modified wedgeshaped head with large, almost oval eyes, and medium low-set ears. The coat is medium length with lustrous, oily guard hairs and minimal undercoat. Females weigh thirteen to seventeen pounds and males from seventeen to twenty-six pounds. Despite the luxurious fur, Siberians are said to produce less of the protein that causes allergy sufferers to sneeze and may be a good choice for allergic people who love cats.

SINGAPURA

The Singapura (below) is a native cat of Singapore. She was known as a Drain Cat because of her habit of sheltering in the city's sewers.

This is the smallest recognized cat breed. Adult Singapuras range in size from four to six pounds. The coat color looks like the Abyssinian, but is much finer and very short, with only dark brown ticking on an ivory ground allowed. The eyes and ears are very large on this stocky but small cat.

The Singapura is a people cat that has never met a stranger. The word curiosity may have been invented to describe this friendly feline. The breed is still relatively uncommon in the United States but growing in popularity.

SNOWSHOE

The Snowshoe developed during the 1970s by breeding a Siamese with a bicolor American Shorthair. That resulted in a medium to large muscular cat with the Siamese point patterns laced with white on the feet, nose, and tummy and striking blue eyes.

The Snowshoe (above) is a lap sitter that prefers to be an only cat and have the owner's attention all to himself. Snowshoes are loving cats. They will accept other animals if they must and enjoy children.

SOMALI

The Somali (below) is identical to the Abyssinian cat, except that she has long silky or thick and wooly fur, with variations in between.

This medium size extremely active athletic cat reminds one of a fox because of her coloring, bushy tail, and full ruff. Like Abys, the Somali is an on-the-go cat who still enjoys a lap-nap after a heady bout of chasing the dog.

SPHYNX

The Sphynx breed is an unusual cat with little or no fur. Such cats have appeared from time to time in the past, but efforts were not made to recognized them as a distinct breed until 1966 when a hairless kitten was born in Ontario, Canada. In 1980, two hairless stray female kittens rescued from the streets of Toronto were subsequently sent to Holland, where they founded the breed we know today.

The Sphynx is not truly bald. He has a peach-fuzz covering of fine down on his body and sometimes very short fur on his muzzle, tail and feet. Sphynx cats come in any coat color or pattern. Early examples of the breed often had genetic problems that

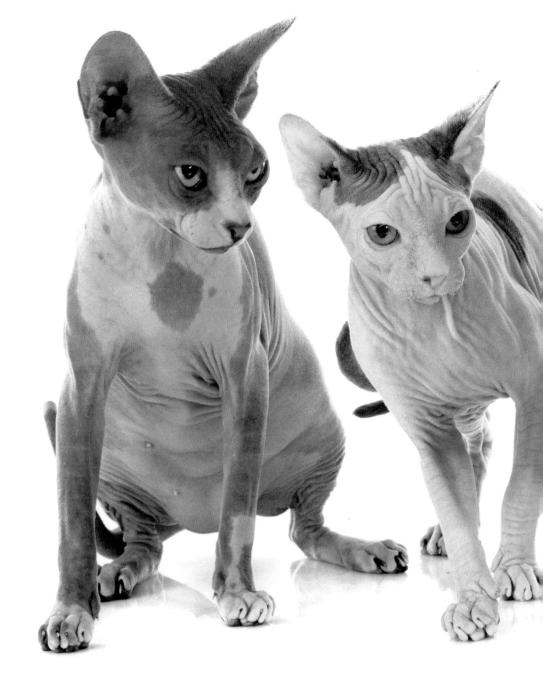

prevented them from developing strong and healthy immune systems. Breeders worked to eliminate these problems.

Sphynx breeder Pat Depew says, "If you sit down, they're right in your lap and come running to you like a little puppy." They have been described as part monkey, part child, part dog, and part cat for their innocent loving natures, athletic ability, and tendency to wag their tails when happy.

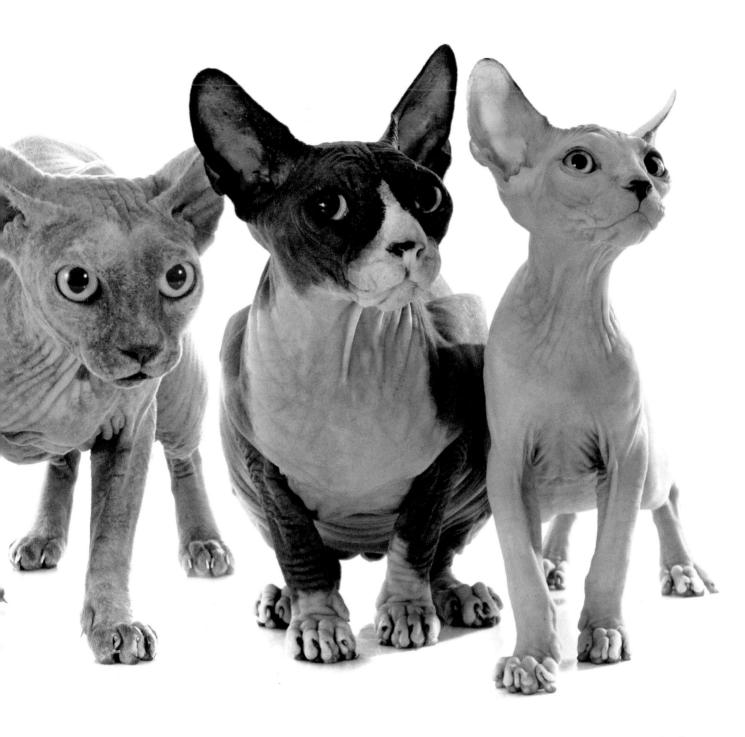

The Sphynx requires frequent bathing to keep his skin clean and control the normal oils that are absorbed into the fur of other cats. The breed is more sensitive to extremes of temperature, and Sphynx body temperature feels a degree or so warmer than other cats. Considered friendly, gregarious cats, Sphynx get along well with other animals.

TONKINESE

The hybrid Tonkinese (below) developed by breeding the foreign type Siamese with the stockier Burmese. That resulted in a medium size pointed cat in mink colors with a body type somewhere between the two parent breeds. To the uninitiated, the Tonk may be confused with an old-style "apple-headed" Siamese. Sometimes called the Golden Siamese, his distinctive aqua to turquoise-colored eyes make him stand out from any other breed.

Breeder Elaine Dunham says the Tonkinese and Burmese have similar personalities. Tonks are vocal like Siamese but less strident. "Tonkinese are like precocious and curious children. Never underestimate them—they refuse to be bored." She suggests establishing rules early, because these intelligent cats will outsmart you given half an inch.

In the Tonk you'll find a combination of the talkative, outgoing Siamese tempered with the gentle and affectionate Burmese nature. This active, intelligent people cat quickly learns how to open drawers and get into all kinds of mischief. These energetic cats seem at home reclining on the tops of refrigerators or scaling even greater heights. Some breeders recommend getting two Tonks; that way, they'll entertain each other rather than get into trouble.

"There are two means of refuge from the miseries of life: music and cats."

TOYGER

This new breed remains in development as breeders work to duplicate the colors and patterns of the tiger. Although he has the tiger's looks and rolling gait, the Toyger (above) has no wild blood. In the late 1980s, Judy Sugden sought to improve the mackerel tabby (striped) markings in her cats. She bred a striped domestic shorthair cat named Scrapmetal to a large Bengal cat called Millwood Rumpled Spotskin, later introducing Jammu Blu to the mix, a street cat from Kashmir, India with the markings she sought. The Toyger gained championship recognition status in 2007.

Rather than vertical stripes or rounded rosettes of other tabbies, Toyger cats sport bold broken or branched dark stripes in a random pattern on a bright orange background. A white ground color covers the underside of the cat, and gold glitter sprinkles over the entire coat. The long rectangular body with high shoulders gives him the low-slung powerful look of the wild tiger. Despite wild appearance, the cat's laid-back personality means he gets along well as a family pet. Toygers love people, and this outgoing friendly feline easily trains to the leash and playing fetch.

TURKISH ANGORA

The Turkish Angora (above), a centuries old breed, originated in the area surrounding the city of Angora (now Ankara), Turkey. The breed is a slim, medium size cat with medium length silky or even wavy fur. Historically, these cats appeared in black, white, dark red, light fawn, mottled gray and smoke colors. Today, we most commonly see this lovely breed in solid white.

The Turkish Angora is an intelligent, affectionate cat that enjoys petting and lap sitting, and loves to play. She is also an opinionated cat and may act stubborn when something isn't to her liking. The luxurious fur has no wooly undercoat, which makes the coat an easy-care low maintenance one.

TURKISH VAN

This ancient breed is a large, muscular cat that arose in the area that today encompasses Iran, Iraq, parts of the old Soviet Union and eastern Turkey. Tradition holds that the cats come from the Lake Van region of ancient Armenia (now Turkey), hence their name. The term "van" refers to color markings on the head and tail with a white body.

Karen Hooker says her Vans never tire of playing fetch. "I wake up in the morning with little paper balls on my head where they've dropped them trying to wake me up to play."

The Van's semi-long easy-care fur has a unique cashmere-like texture. The fur is waterproof, and these cats love the water. They are called "swimming cats" in their native region. The white body color is highlighted with markings typically set in a cap of color on the head and ears, the tail, and sometimes the back. A color mark on the shoulders is particularly prized and referred to as the "thumbprint of Allah."

"Once it has given its love, what absolute confidence, what fidelity of affection! It will make itself the companion of your hours of work, of loneliness, or of sadness. It will lie the whole evening on your knee, purring and happy in your society, and leaving the company of creatures of its own society to be with you."

Theophile Gautier

CONCLUSION

his book has been a delight to prepare. I hope you'll share the tips and tricks, facts and fables found in these pages to introduce others to the joy of being cat owned.

It was my intention to answer many questions, but I also wanted to whet your appetite for more. Learning about *Felis silvestris catus* is an ongoing adventure for us all and educating ourselves can only help us be better caretakers for these mischievous, alluring creatures we call cats. You'll find more cat-centric references from Furry Muse Publishing on the next page.

Kitty has traveled thousands of miles and hundreds of centuries to snuggle in our laps today. Responsible cat lovers like you will ensure that she continues to hold a special place as a valued companion and pampered pet in the hearts of future generations. My own furry muse, Karma-Kat (below) sends his purr-sonal greetings.

Whisker twitches and kitty kisses; kneading paws and fluffy purrs; damp noses and velvet cheeks; tongue tickles and shoulder perches. A small, warm fur-child winds about your ankles, sending her message in unmistakable felinese. No matter how she shows it, the action speaks louder than words; warm, furry, unconditional LOVE.

Oh beautiful, mysterious Cat, the feeling is so mutual!

FURTHER

READING

Cat Facts: The Pet Parent's A-to-Z Home Care Encyclopedia by Amy Shojai

Complete Kitten Care by Amy Shojai

ComPETability: Solving Behavior Problems in Your Multi-CAT Household by Amy Shojai

ComPETability: Solving Behavior Problems in Your CAT-DOG Household by Amy Shojai

Complete Care for Your Aging Cat by Amy Shojai

New Choices in Natural Healing for Dogs and Cats by Amy Shojai

The First-Aid Companion for Dogs and Cats by Amy Shojai

FURRY MUSE Publishing

A

Abscesses, 93

Abyssinians, 107

Acne, 93

African Wildcat, 15, 25, 29

Ailurophiles And Ailurophobes, Noted Personages, 9

Altering, 79

American Bobtail, 107

American Curl, 107

American Wirehair, 104, 108

Anatomy, 63-64

Antifreeze, As Poison, 103

Arthritis, 76, 97

Asphyxiation, 95

Aspirin, Toxcity Of, 104

В

Bad Cats, Superstitions Surrounding, 62-63

Balance, 70

Balinese, 109

Beauty, 29, 65, 120

Bengal, 109

Birman, 110

Body Position, 86

Bombay, 102, 104, 110

Bowls, 88, 93, 102

Breeding, 16-17, 36, 79-81, 102, 108-112, 117, 121, 126, 129

Bubonic, 35

Burmese, 59, 110-112, 129

Burmilla, 112

C

Calicivirus, 91

California Spangle, 112

Cancer, 97

Carnivores, 72

Cat Toys, 84

Catabolism, 93

Catnip, 44, 72, 77, 88

Chartreux, 104, 112

Cheetah, 14, 21, 23, 24, 116

Chemical, 72

Classification, Species List, 29

Claws, 12, 21-24, 63-65, 76-77, 82-89

Clouded Leopard, 14, 21

Color Perception, 66

Colorpoint Shorthair, 112

Cornish Rex, 113

Creation Fables, 54

Creodonts, 11

Cymric, 120

D

Declaw, 76

Deities, 28-29, 35, 47, 55

Devon Rex, 104, 114

Diabetes Mellitus, 93

Diarrhea, 87, 91, 97, 101

Dilated Cardiomyopathy, 97

Diseases, 91

Distemper, 91

Dreams, 65, 81

Drinking, 93

Е

Ear Mite, 92

Eating, 21, 31, 72, 77, 81, 87, 89, 92, 97

Egyptian Mau, 116

Epilepsy, 93

Euthanasia, 94, 98

Evolution, 12, 16

Extrasensory Perception, 60

Eye Dilation And Mood Of Cat, 85

Eyes, 16-17, 20-25, 29-34, 42, 65-66, 82-85, 91, 101-102, 107-129

F

Falling, Balance And, 70

Feeding, 87

Felinae, 12, 14

Feline Aids (FIV), 91

Feline Infectious Peritonitis (FIP), 94

Feline Leukemia, 91

Feline Lower Urinary Tract Disease (FLUTD), 94

Feline Panleukopenia, 91

Feline Rhinotracheitis, 91

Fishing Cat, 24

Flat-Headed Cat, 24

Fleas, 92

Fur, Coat Types, 104

G

Gestation, 91

Geriatric Medical Concerns, 97

Ghost Cats, 51, 61

Good Cats Superstitions, 59

Grass Eating, 88 Grooming, 93

Н

Haemobartonella, 92
Havana Brown, 117
Haw (Nictitating Membrane), 69
Heart Disease, 97
Heartworms, 92
Heat, Cats' Insensitivity To, 75
Heraldry, Cats In,, 50
Himalayan, 117
Hookworms, 92
Houseplants, Hazards From, 102, 107

Hunting, 29, 51, 72, 88, 108

Hyperthyroidism, 97

I

Illness, 91-98 Insecticides, 92

Jacobson's Organ (Vomero-Nasal Organ), 71

Jaguar, 12

Japanese Bobtail, 118

Javanese, 118

K

Kittens, 82

Kittens, Eyes Opening, 82

Kittens, Feeding, 82

Korat, 118

L

Labor, 81 Leopard, 16, 20-21, 24, 29, 109-110 Lion, 17

Literature, 39

Litter Box, 76

T_1_: 110

Lykoi, 119

Lymphosarcoma, 97

Lynx, 12, 23, 25, 113

M

Machairodonts, 12 Maine Coon, 119

Man Eaters, 20

Mange, 92

Manx, 102, 112-113, 118, 120

Marriage, Cat Folklore Surrounding, 59

Medicine, 90

Miacid, 12

Milk, 34, 42, 81-82, 87, 92

Mobility And Activity, 63

Moods, Discerning Of, 85

Motor Skills, Play For Development Of, 83

Movies, 52

Music, Cats' Predilections For, 44

N

Naming Of Cats, Internationally, 28

Nasal Cavities, 71

Natural, 132

Neofelids, 12

Neutering, 78

Nictitating Membrane (Haw), 69

Norwegian Forest Cat, 120

Nose, 30, 39, 71-75, 89-91, 95, 101, 114, 116-118, 126

O

Obesity, 93

Ocicat, 121

Opera Cats, 44

P

Paleo Felids, 12

Pallas's Cat, 25

Parasites, 92

Paw Pads, Sensitivity Of,, 74

Periodontal Disease, 73

Persian, 25, 36, 102, 110, 116-117, 122, 124

Play, 55, 82-85, 89, 101, 108, 118, 125, 130

Plants, Hazards From, 102, 107

Poison, 36

Population Control, 78

Pregnancy, 81

Protein Requirement, 87

Psi-Trailing, 60

Purring, 18

R

Ragamuffin, 122

Ragdoll, 122

Registering Associations, 106

Religion, 34

Reproduction, 81

Roundworms, 92

Russian Blue, 123

Rusty-Spotted Cat, 24

S

Saber Tooth Cat, 12 Scent, 71 Scottish Fold, 102, 123, 124 Scratching, 60, 76-77, 85, 92 Siamese, 42-43, 52, 59-60, 81, 93, 102, 107-113, 117-118, 121-129 Siberian, 125 Singapura, 125 Size Ranges, 14 Sleeping, 65 Small Cats, 24 Smell, 71-73, 82, 89, 107 Snowshoe, 126 Somali, 126 Sound Sense, 69 Spaying, 79 Sphynx, 102, 104, 127,-128 Stud Tail, 93

Superstitions, 57-60 Sweat Glands, 74 Symbolism, Cats And, 48

T

Tails, 14, 63, 85, 107, 119-120, 127 Tapeworms, 92 Taste, 73 Threadworms, 92 Ticks, 92 Tiger, 16, 20, 32, 45, 66, 110 Time Sense, 60 Tonkinese, 129 Touch, Sense Of, 74 Toyger, 129 Training, 82 Tuna, As Poor Food, 99 Turkish Angora, 130 Turkish Van, 130 Tylenol, 104

U

Urine, 89-90, 94

V

Vaccinations, 91 Veterinary Care, 90 Vocalizations, 17 Vomero-Nasal Organ, 71

W

War Cats, 40 Water, 88 Weather, Cat Folklore Surrounding,, 59 Whipworms, 92 Whiskers, 16, 65, 74, 85, 88, 104, 108, 124 Wildcats, 14, 15, 23 Working Cats, 51

ABOUT THE AUTHOR

Amy Shojai (www.SHOJAI.com) is a certified animal behavior consultant, and the awardwinning author of more than 30 bestselling pet books that cover furry babies to old fogies, first aid to natural healing, and behavior/training to Chicken Soupicity. She has been featured as an expert in hundreds of print venues including The New York Times, The Wall Street Journal, Readers' Digest, and Family Circle, as well as television networks such as CNN, and Animal Planet. Amy brings her unique pet-centric viewpoint to public appearances. She is also a playwright and co-author of STRAYS, THE MUSICAL and the author of the critically acclaimed September & Shadow pet-centric thriller series. Amy lives in Texas with her furry muses.